STYLE

Legends, Rebels, & Visionaries

ILLUSTRATED BY BIJOU KARMAN

INTRODUCTION BY BOOTH MOORE

ESSAYS BY SARA DEGONIA

CHRONICLE CHROMA

Table of Contents

Introduction

If fashion is the language, style is the fluency, and with a little imagination, everyone has the potential to be an icon in their own fan circle.

For inspiration, *Style Legends, Rebels, and Visionaries* features fifty experts from the 1950s to today, delightfully illustrated by Bijou Karman. Every colorful, detailed portrait captures the personality of each individual and the essence of their particular style. It's an inclusive and eclectic list that proves the real key to individuality is being fearless enough to go your own way.

Harry Styles with his flamboyant suits and feather boas. Frida Kahlo with her traditional Mexican dresses and flower crowns. Tyler, the Creator with his nerd sweaters and fur trapper hats. There are those whose personal style is writ so large on the collective consciousness it's shorthand for who they are.

For more than three-quarters of a century, Iris Apfel has inspired designers and museum curators with her shock of white hair, signature saucer-sized eyeglasses, tangle of necklaces, and statement coats. At age 101, she is still a tsunami of style, and her mantra, "More is more and less is a bore," is one to live by now more than ever.

Because we are in a golden era of personal style, living on screens, where image is almost everything, personality is as valuable as pedigree, and everyone has their own media platform to broadcast 24/7.

In a cluttered content landscape, how you put yourself together is how you stand out, whether it's on a concert stage or in a Zoom meeting.

Having great style can be as simple as a shade of lipstick or pair of glasses specific to you. (Arts patron and heiress Peggy Guggenheim understood that, making her butterfly-shaped glasses her trademark.) It can be achieved by partnering with a fashion designer. But with today's melding of high and low culture, past, present, and future, new and vintage, it doesn't have to be expensive and is often better when it's not.

As the king of kitsch director John Waters has said, "You don't need fashion designers when you are young. Have faith in your own bad taste. Buy the cheapest thing in your local thrift shop—the clothes that are freshly out of style with even the hippest people a few years older than you. Get on the fashion nerves of your peers, not your parents—that is the key to fashion leadership."

More than any other, perhaps, the music industry has always understood the need for a signature look. Elton John's bold glasses, bedazzled Dodgers baseball uniform, "Crocodile Rock" rainbow feather jumpsuit, and decades' more over-the-top looks cemented his pop culture image and gave

fans reason to dress up and emulate him during the recent Farewell Yellow Brick Road tour.

"Throughout my career, clothes have been so important. Without that process of dressing up and looking different and having fun, I would never have been the artist that I became, never," John has said.

Billie Eilish developed her own skater kid/mall goth style to signal she was breaking the mold of the sexualized young female pop star. Meanwhile, Rihanna made pregnancy style sexy, upending generations' old ideas of what having a baby looks like.

It's no wonder that the fashion business isn't solely driven by designers anymore; it's driven by the personalities they get to wear their clothes, with Gucci, Dior, Louis Vuitton, Loewe, and many other brands tapping celebrities and style icons for campaigns and collaborations, and soaking up some of their genius by association.

Up until his recent departure, Gucci creative director Alessandro Michele made individual style the building block of his design approach. Rather than showing runway collections with themes, he showed characters you might see on the stage, on the street, mixing references, and putting granny clothes on a man and children's clothes on a woman, for example.

Blurring the line between costume and everyday clothing, he reveled in the unexpected, as do so many style icons and legends, including Gucci collaborator Styles, the Gen Z gender bender who became the first solo male to grace the cover of *Vogue* magazine.

"I'll go in shops sometimes, and I just find myself looking at the women's clothes thinking they're amazing. It's like anything—anytime you're putting barriers up in your own life, you're just limiting yourself," he has said.

This is the golden age of personal style because expression has been freed of gender, thanks also to rebels like Timothée Chalamet, who pushed the envelope of what a sex symbol looks like on the red carpet at the 2022 Venice Film Festival, wearing a draped red silk backless halter jumpsuit by designer Haider Ackermann.

"I would rather be handsome . . . for an hour than pretty for a week," said Tilda Swinton, another gender-defying star, whose alien-like visage makes her a perfect chameleon for designers and directors.

Indeed, beyond creating a shorthand to visual identity, many of the icons in this book use their style as part of a greater aesthetic purpose—the extension of art to self.

For Kahlo, the traditional Tehuana garments, painted plaster corsets, jewelry, and floral headdresses are synonymous with her artwork, projecting pride in her Mexican heritage while disguising debilitating injuries sustained in a traffic accident.

Artist Yayoi Kusama's use of polka dots extends from canvas to her person, with her signature red, chin-length wig and patterned dresses a canny self-promotion for the former fashion designer.

Interestingly, the unconventionally pretty often have a particular knack for stylish self-invention. Take Diana Vreeland, who, despite not being a traditional beauty, became the arbiter of all things beautiful at *Vogue* magazine, creating an indelible image of what a fashion editor should look like with her immaculate bob, red lipstick and nails, long pearls, and cuff bracelets.

Similarly, Hollywood costume designer Edith Head's bob, heavy black glasses, and two-piece suits became so recognizable they were used in the animated film *The Incredibles* as a visual nod to establish the authority of superhero suit designer Edna Mode.

There's something to the idea of stylish self-image so powerful it can be recognized from broad strokes on a screen, or beautiful renderings on a page, as in this book. Enjoy.

—Booth Moore

Wes Anderson

"The things that are more my own style are something that I don't really have to think about. The only time I have to think about them is if I want to force myself not to do it the way I do it."

Wes Anderson met Owen Wilson in college when they were both eighteen years old. "I was studying philosophy, and he was studying English. But we met in a playwriting class. We first started talking about writers, but we also talked about movies right off the bat. I knew I wanted to do something with movies. I don't know if he had realized yet that it was an option."

Anderson realized his future path fairly soon, but it took Wilson a bit longer to recognize his potential as the hugely successful comedic actor he is today.

"We started writing together. I was always going to be the director, but he didn't really want to be an actor—or I don't know if he knew he wanted to be an actor. As far as he was concerned, he was strictly a writer."

Each made their way into the industry, Anderson taking inspiration from Alfred Hitchcock, Stanley Kubrick, Martin Scorsese, and Jean-Luc Godard to carve out the stylized niche he's established as a celebrated film director.

"I've done a bunch of movies. And it's a luxury to me that they're all whatever I've wanted them to be."

It's easy to recognize a Wes Anderson film, although perhaps not as straightforward to box his perspective into one small, neat package. And who would want to?

"I do feel kind of like I've got my own style and voice."

His cinematography features retro touches and color palettes that alternate between jewel tones and more muted earth shades. He takes inspiration from a film's location to set the stage.

"What I like to do is go to a place and have us all live there and become a real local sort of production, like a little theater company—everything works better for me that way."

And although he's worked with various costume designers—Karen Patch, Kasia Walicka-Maimone, Oscar-winning Milena Canonero—his characters share a certain fashion sensibility, showcasing vintage fashions, playful proportions, and eclectic patterns.

"I do feel a bit like my characters from one movie could walk into another one of my movies and it would make sense."

Shying away from the spotlight himself, Anderson's personal preferences aren't necessarily his focus; he has a penchant for corduroy, Clark's Wallabees, and New York tailor Mr Ned. At the premiere of *The French Dispatch* at the Cannes Film Festival in 2021, Anderson impressed in a seersucker suit, knit tie, and white penny loafers.

He also enjoys a close relationship with Prada, commissioned Louis Vuitton to make luggage and Marc Jacobs to design suits for the lead actors in *The Darjeeling Limited*, and drafted Adidas to produce Steve Zissou's shoes for *The Life Aquatic*.

Many of the costumes from his films seem to have influenced future fashion collections, including Alessandro Michele's first Gucci collection in 2015, following the release of *The Royal Tenenbaums* and Gwyneth Paltrow's iconic portrayal of Margot Tenenbaum, complete with a Fendi belted mink coat and Hermès Birkin.

So what exactly defines the concept of a Wes Anderson movie? Even the filmmaker himself can't pin it down. "The more I think about it, the more confused I get."

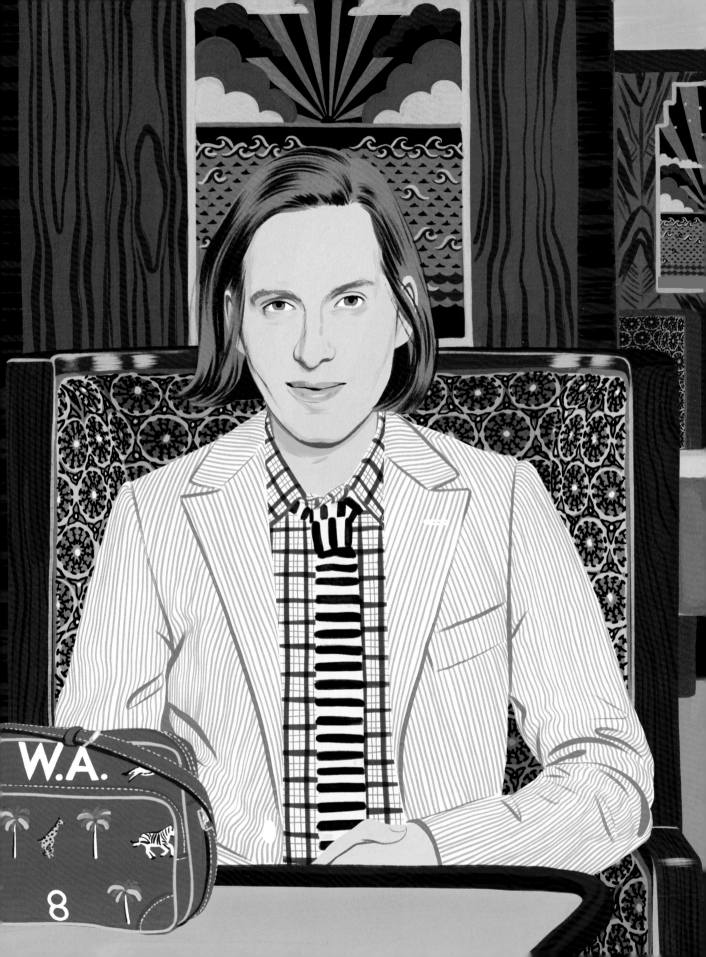

Iris Apfel

"Fashion you can buy, but style you possess. The key to style is learning who you are, which takes years. There's no how-to road map to style. It's about self-expression and, above all, attitude."

She's iconic. She's legendary. She's a cool 101 years old.

Whether through her textile firm, as a professor of apparel, as the author of her autobiography (*Iris Apfel: Accidental Icon*), or as the inspiration for the oldest Barbie ever created, Iris Apfel has brought color and joy to the world through her work and passion for a century—a longevity in fashion that few (if any) can replicate.

Born August 29, 1921, Apfel grew up in Queens, New York, studied art history at New York University and art education at the University of Wisconsin, and became a copywriter for *Women's Wear Daily*. She married her husband, Carl Apfel, in 1948, and in 1950 they launched Old World Weavers, which they ran together until 1992.

Choosing what she's best known for is no easy task. Many will know Apfel from collaborating (alongside her husband) with nine first ladies on the interior design during their White House tenures. Others will remember that model agency IMG signed her at age ninety-seven. And don't forget the documentary, aptly titled *Iris*.

In 2005, a curator from the Metropolitan Museum of Art's Costume Institute called her up to create a show from her personal collection of vintage and designer accessories and clothes. Apfel styled the mannequins herself, and the exhibition was a huge success.

"I think some people like me because I'm different. I don't think like everybody else. People are so tied up in the worst parts of technology these days. . . . They don't use their imaginations."

In her nineties Apfel modeled for Kate Spade, Alexis Bittar, and M.A.C. cosmetics, and inspired a kitchen collection of chic applicances.

She's been described as "charmingly rude," "brilliantly abrupt," and a "handful," and what else would you expect from someone of her stature?

One look at Apfel's Instagram page—with her giant, circular, black-frame glasses and oversized necklaces—is all you need to instantly believe in her powerful presence. She epitomizes boldness, possesses charisma out the wazoo, and her view of fashion can be summed up perfectly by the simple sentiment on her profile—"More is more and less is a bore."

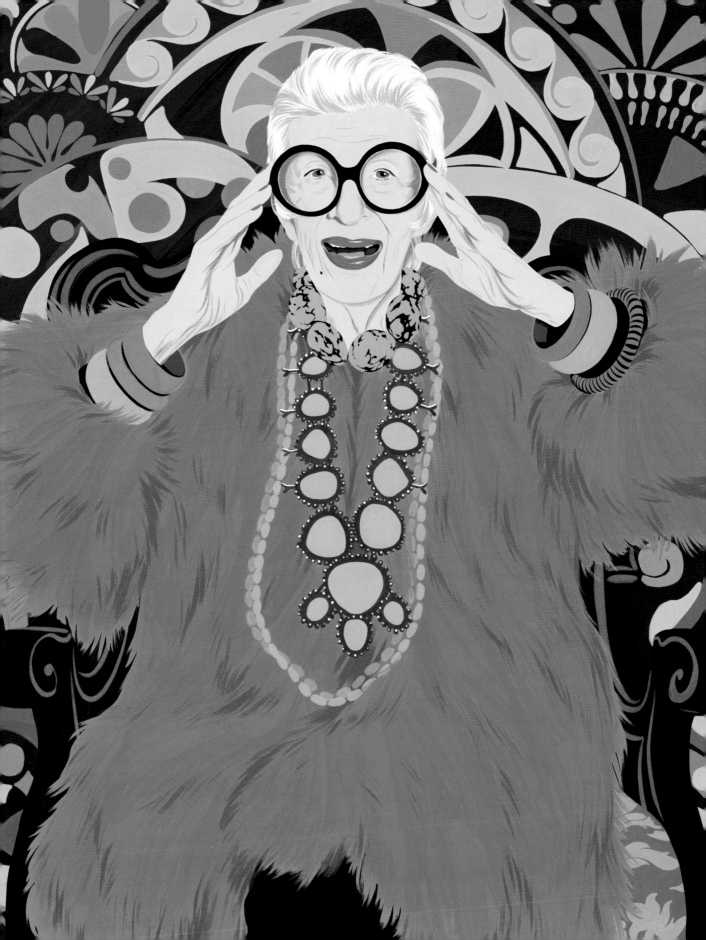

Erykah Badu

"I love that the garments that I get to wear have sound and movement and make music. The beads and metal pieces and things that I constantly add to my wardrobe are parts of what makes me, me. I love my clothes to sing."

"Music was a big part of my life." Born and raised in Dallas (Erica Abi Wright), Erykah Badu said, "We had a radio in the bathroom of my maternal grandmother's house that never went off. My paternal grandfather bought me a piano when I was seven years old. No music lessons. Just: 'Here's a piano.' And I was able to get up on it and write songs. I think I wrote twenty songs in the first week."

Badu broke out in the late nineties in the neo-soul scene. In 1997, she said, "Music is kind of sick. It's going through a rebirthing process, and I found myself being one of the midwives." And later, "I don't know what I was talking about back in 1997, but I was committed to it, whatever it was, and I've continued to evolve."

Much like her early introduction to music, Badu remembers fashion playing a role in her life as a child as well. "My first real [fashion] influence or memory is when I was a little kid. I have always been attracted to things that don't conform. When I was entering high school, everybody was kind of avant-garde there. There were musicians, singers, painters, and I said, 'Oh, this is what we are doing? Okay.' It gave me the confidence to be a free spirit and express myself. I saw the kids dressing in different kinds of ways and being influenced by punk rock, Europe, and Japan, and making their own clothes. I was surrounded by that kind of thing in high school and it became my world. My mom is pretty stylish too!"

Her relationship with fashion has only grown as her career has advanced. "My closets look like full rooms. I am a collector, after all." Badu's collection hasn't dwindled since the nineties. In her Dallas home, she has "two big dressing rooms, and a few small closets . . . and storage."

Badu browses H. Lorenzo in LA or Dover Street Market in NYC. She's a fan of Oscar de la Renta, Valentino, and Jean Paul Gaultier.

"I have a good understanding of my own personal style. [I know] what looks good on my body, what colors look good on my skin. I'm not afraid to take risks. I mean, it's all creativity. Whether it's writing a song or doing a dance or making a film. I feel like I'm witnessing myself. I'm my own audience."

Badu has worked with designers such as Bode, CDLM, ERL, Dior, Balmain, Raf Simons, and Rick Owens. She has also collaborated with Gunner Foxx, a milliner in Los Angeles who uses nineteenth-century techniques.

"I call fashion 'functional art.' Art that moves with you and changes with you, that forms to fit your mood. It's all art: the way I read, the way I cook, the way I do my hair, all of it is some kind of aesthetic that makes me happy—that makes me feel good. I don't feel obligated to do any particular thing. I am just quite intuitive with what feels and looks good artistically."

In fact, in 2020, Badu opened Web shop Badu World Market, a collaboration with artists, designers, and artisans she discovers and respects.

"I have the advantage [that] my job is to create, my whole mindset is creation whether it's food or fashion or education or art."

Known as the "Queen" or "Godmother of Soul," Badu has released five studio albums and earned four Grammy Awards. Of the nicknames, she said, "I can see the evidence of that when I listen to music or hear young artists talk and they're not shy at all about telling me thank you for the things I've contributed to them."

Badu has walked the Valentino runway (wearing the brand's signature pink, complete with a floor-length feathered cape and oversized chapeau), served as the face of Tom Ford fragrance, and deejayed at a Burberry house party.

Her plans for the future are varied and vast: "I want to have a variety show. I want to get my midwifery certification in direct-entry midwifery. I want to build schools. I want to join the Peace Corps. I want to paint more seriously. I want to help my children with their dreams."

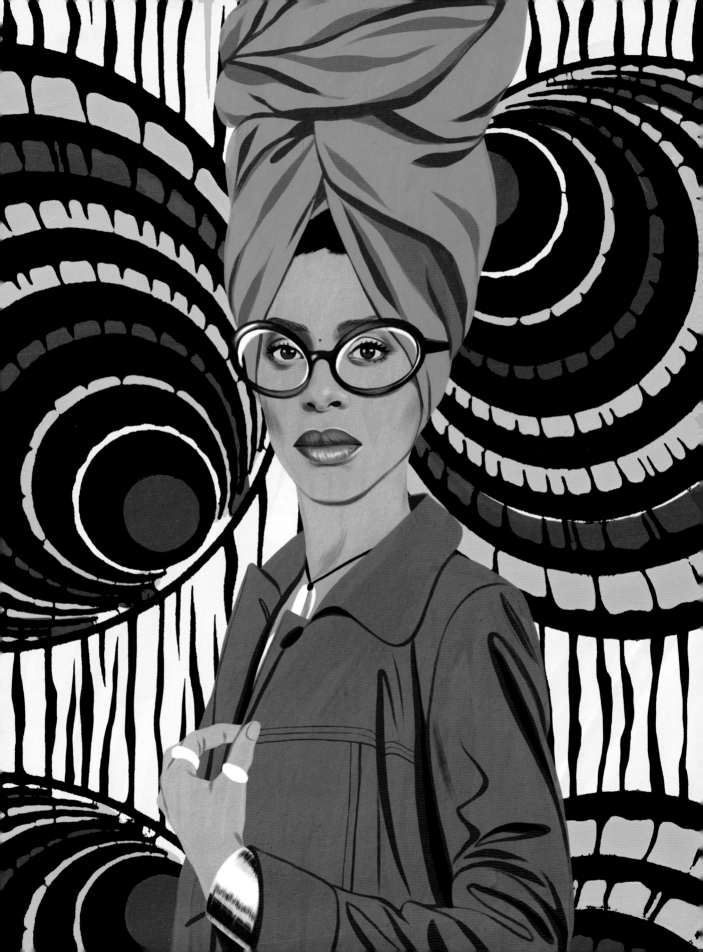

David Bowie

"Fashion is something I have always been fascinated with, but I've never felt the need to be fashionable myself. I enjoyed it when I was young, and of course I used fashion when it was necessary in my work, but I have never considered myself to be a fashionable person. Not at all."

Whether you know him as Ziggy Stardust or David Bowie, there's little doubt that you know something of the influential British musician, actor, and all-around showman.

Born David Jones, he picked up the saxophone at thirteen and a few years later began performing with other bands and leading a group called Davy Jones and the Lower Third. But not to be confused with The Monkees' Davy Jones, he changed his name to Bowie and struck out on his own.

Unable to initially find solo success, Bowie took a break from music, including a stint at a Buddhist monastery. But, in 1969, he returned to his passion and released "Space Oddity," inspired by *2001: A Space Odyssey*. From there, Bowie's career exploded, reaching new heights in 1972 with *The Rise and Fall of Ziggy Stardust and the Spiders from Mars*.

As Ziggy Stardust, Bowie wore outlandish, sci-fi costumes, laying the foundation for his lifelong status as a fashion inspiration.

"I always had a repulsive sort of need to be something more than human," he said. "I felt very puny as a human. I thought, 'Fuck that. I want to be superman.'"

Designers Kansai Yamamoto and Freddie Burretti created a significant portion of Bowie's most famous looks in the seventies, an aesthetic he called "half out of sci-fi rock and half out of Japanese theater."

As his career evolved—producing, shifting his musical style, and appearing on Broadway—so did his style. He could appear androgynous or dapper, preppy or in full mime makeup; he could wear a floral dress on his album cover, dress to impress in a three-piece suit on the *Cher Show*, or rock an Alexander McQueen Union Jack coat in the nineties on tour.

"I think that my fascination with clothes generally was motivated by trying to create characters for the stage. If I wasn't going through a thing where I was also being my characters offstage, I'm much happier just wearing the most low-profile things that I can come up with just so I can get down the street."

Bowie starred in films like *The Man Who Fell to Earth* and cult classic *Labyrinth*. He is widely known as one of the most influential entertainers of the twentieth century—inducted in the Rock and Roll Hall of Fame in 1996 and receiving the Grammy Lifetime Achievement Award in 2006.

"When I go out onto a stage, I try to make the performance as good and as interesting as possible, and I don't just mean singing my songs and moving off. I think if you're really going to entertain an audience, then you have to look the part too."

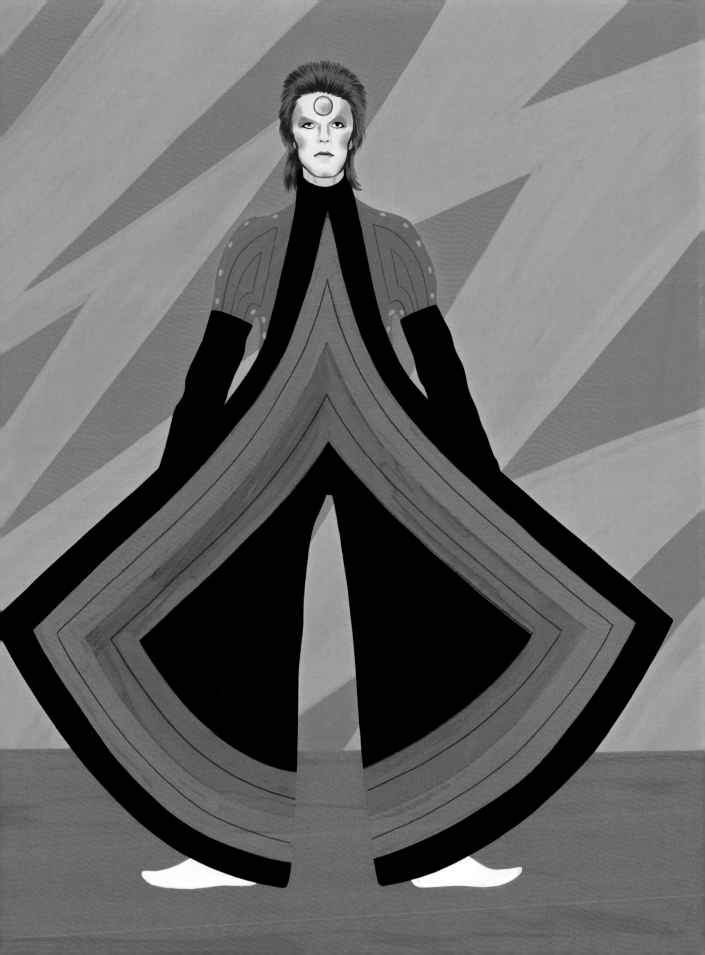

Thom Browne

"I would rather someone really hate my work than them just 'liking' it. If you want to move things forward, you have to challenge people in both positive and negative ways."

After studying economics at Notre Dame and pursuing a very brief career in business consulting, Thom Browne moved to LA to find a new path. He appeared in some commercials in the nineties, worked as a production assistant, and with Libertine's Johnson Hartig, began reimagining vintage clothing. It wasn't a goal he'd set for himself growing up ("I had no creative expression"), but when he couldn't find the old gray-flannel-suit style he had in mind from days of yore, Browne began working with tailor Rocco Ciccarelli to make the suits he envisioned.

He raised $100,000 from his siblings and set up an appointment-only shop in Manhattan. Initially, his short suit jackets with snug shoulders and ankle-baring trousers were met with trepidation.

"I had friends say, 'Thom, why would I want it? It doesn't even look like it fits *you*.'"

But slowly his vision began to resonate, despite his nontraditional entry into the industry.

"I don't know that much about fashion, and I consciously don't *want* to know that much about fashion—I was never really schooled in it, and I didn't grow up surrounded by it. I'm more of an instinctual designer—I create things that are interesting to me."

Whatever his method, it has worked out just fine. His clientele includes Jimmy Fallon, Erykah Badu, Pete Davidson, and Michelle Obama, whom he dressed for President Barack Obama's second inauguration.

"The approach for her was making sure she was in something as strong and as interesting and as important as she is. That's all I cared about. I didn't care about it being a fashion moment; I cared about it being something that stood up to her. That was what was so gratifying for me is when I saw her walking down the Mall with the president, she just looked so—she looked strong, she looked feminine, she looked so cool. There was so much about it that was so gratifying."

Browne launched his womenswear line in 2011, expanded menswear beyond the suit, and branched out into many other areas, including swimwear and childrenswear.

"I want the men's collection to be as feminine as possible and the women's collection to be as masculine as possible, because I love the idea of men's and women's worlds becoming connected. My design team is like, 'Pretty is not always so bad.' But I don't want pretty! Sometimes I want it to be ugly. In it being ugly, it could be so interesting and, in a *weird* way, pretty."

Named the new chair of the Council of Fashion Designers of America in 2022 (succeeding Tom Ford), Browne has undoubtedly earned his place after launching his distinctive line twenty years ago.

"The most important thing is just staying true to yourself. And don't get into it if you want to make money. It sounds so simplistic, but if you're getting into it to make money, you fall into the commercial trap of not creating interesting things, and when you're at the beginning you have to set the foundation of creating what you're about, and that's not commercial. That has to be so personal and so intimate that not everyone is going to get it."

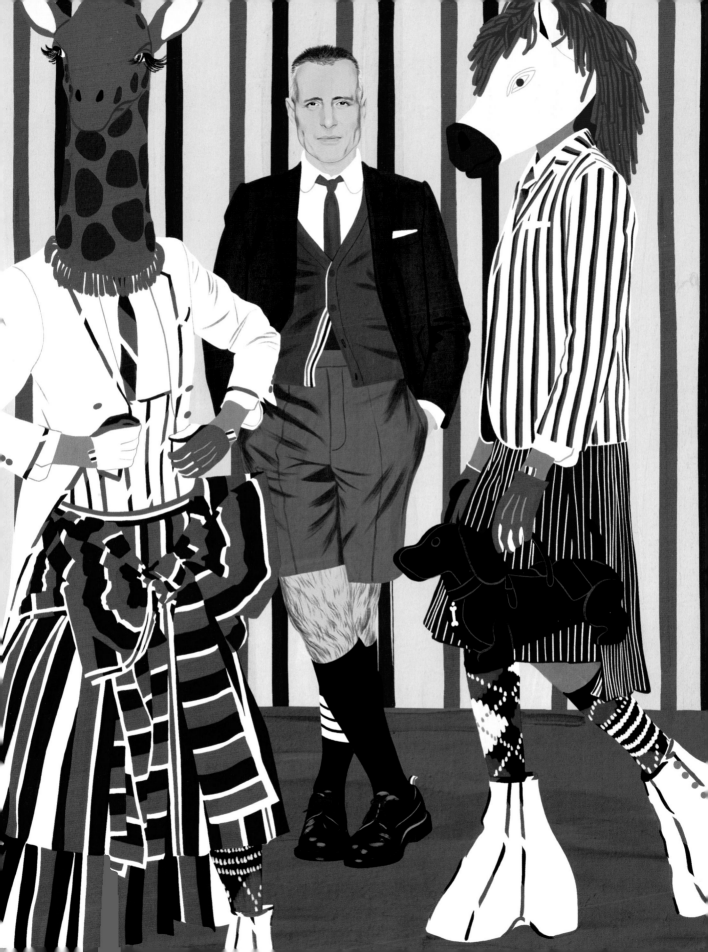

Timothée Chalamet

"I've always loved the idea that you can appropriately express yourself through clothes."

Turning heads since his first Oscar nomination at age twenty-six, Timothée Chalamet brings boldness to every red-carpet look.

Call it a gender-fluid aesthetic, call it avant-garde, the *Call Me By Your Name* star's fashion sense commands the kind of attention that earned him the first solo male cover of *British Vogue*. Far from the ultra-macho façade that described many male sex symbols of previous generations, Chalamet falls decidedly into the newer "artthrob" category coined by writer Anne T. Donahue.

He's worn Prada, Cartier, and Alexander McQueen, just to name a few, showcasing looks that include bold red flowers, Swarovski crystals, and plenty of pink. He chose Stella McCartney suits to promote a pair of films—magenta for *Little Women*, and a blue-and-cream mushroom print for *Dune*.

Chalamet's taste, be it tailored suits, black boots, or a Louis Vuitton harness, reflects a confidence that many at his age can struggle to obtain—and he can relate. "I think when you're growing up, you always feel out of your body, looking in the mirror to confirm your identity or to shred your identity or to hate yourself," he told *Glamour UK* in 2021. "That's

probably the most challenging period in life, when you're truly the fish out of water. But the brilliance in that too is then you search for your identity, you search for what makes you feel grounded, and you find the good people in your life."

The 2022 Venice Film Festival offered yet another opportunity for Timothée's individual style to appear, as he donned a shimmery-red halter jumpsuit by friend and reported favorite designer, Haider Ackermann. The flowy, backless monochrome ensemble turned heads at the premiere of *Bones and All*.

And his penchant for fashion goes beyond stunning followers and paparazzi alike. In 2021, he and Ackermann announced the launch of a charitable clothing initiative to benefit Afghanistan Libre, an organization that fights for women's and children's rights.

Maybe Chalamet isn't the first to embrace pieces outside of the masculine norms, but there's no doubt that he's representing a mix of genres with a certain confidence and flair. With, by all appearances, a long career ahead of him, fans should have plenty of opportunity to enjoy the individual style of Timothée Chalamet for decades to come.

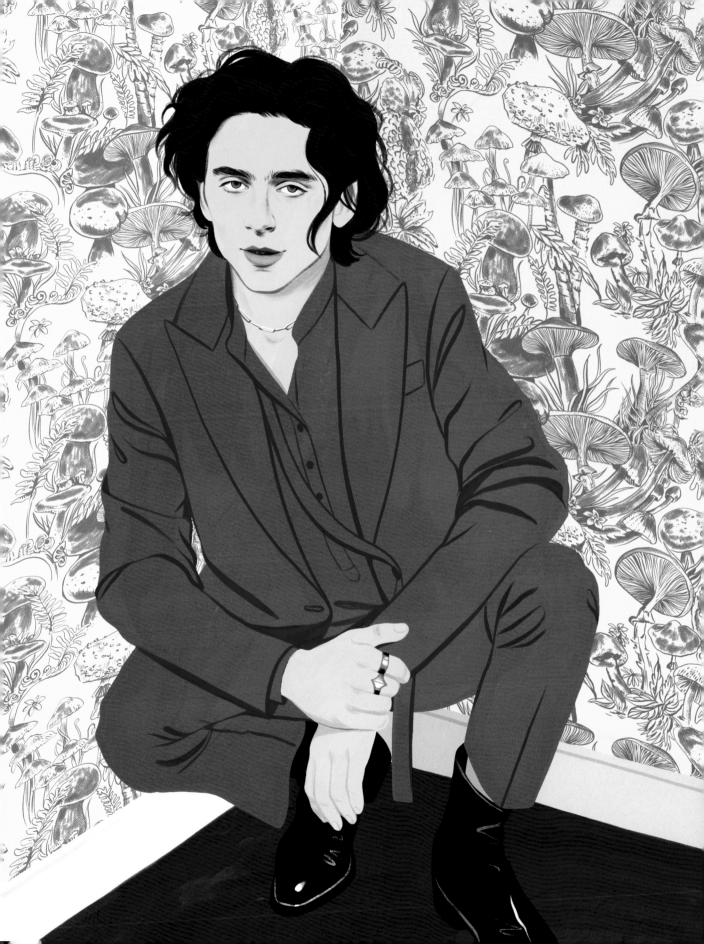

Cher

"I like what I like, and I don't care what the fashion is. You have to wear what's good for your body. It doesn't even make any difference how in-fashion you are if you look like shit."

Whether it be her straight, black, waist-length hair, barely-there costumes, or that husky voice you could pick out of a crowd, Cher has been serving up "goddess of pop" for more than five decades.

First gaining popularity in the sixties with her husband as singing duo Sonny & Cher, her fashion sense became part of the package from day one, showing off fur vests, kohl eyeliner, and so many bell-bottoms on those long, long legs—not to mention the first female-bared navel on television. "We had a look that people just really didn't understand at all," she told *Vogue* magazine in 2022. "We were so proud of our look and our clothes, but we couldn't get on a lot of shows. I mean even The Beatles wore little suits."

Cher first teamed up with Bob Mackie in 1967 when she guest-starred on *The Carol Burnett Show*, where Mackie worked as costume designer. Their collaboration grew from there as he designed her looks for *The Sonny and Cher Show*, red-carpet runways, and multiple tours. "Bob Mackie was so ahead of everyone, and he had the luxury of me never caring

what it was. It was never too little, it was never too much bling. I was always thrilled with everything he gave me." In 1974, Cher attended the Met Gala wearing Mackie's "naked dress"—a sheer, beaded gown with white feathers flowing from the sleeves and skirt.

And if the world had been living under a rock before then, her look at the 1986 Oscars, complete with towering feather headdress and black-sequined, midriff-baring gown, not-so-subtly announced her well-earned place on the map.

Singing, acting, and entertaining for the majority of her life, Cher has performed her role as style icon as well as the rest. Ostrich feathers, glittering headdresses, nipple pasties, and leather capes, even as an Egyptian goddess, Cher has presented a signature diva image throughout her entire career—with, fortunately, no signs of slowing down anytime soon. Thankfully, for fans, that means walking the Balmain runway during Paris Fashion Week at seventy-six, dressed in head-to-toe black spandex and platform boots, giving us that glamour that only Cher can deliver.

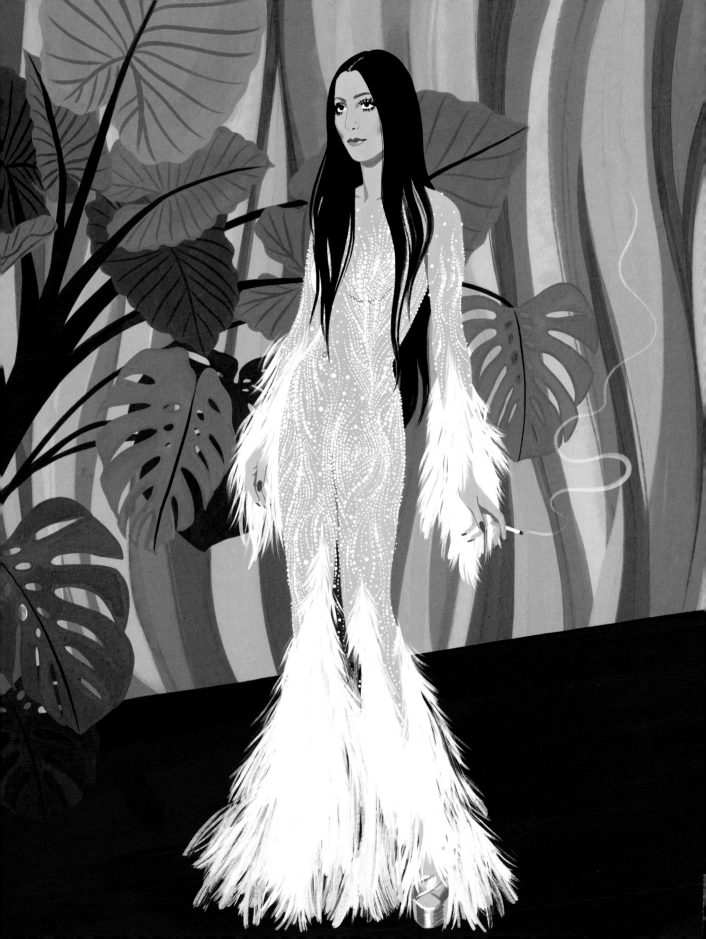

Quannah Chasinghorse

"Being able to be an Indigenous youth in this space is so important. I grew up never seeing any representation—now I get to be that person for a lot of others."

With her striking features and traditional face tattoo, Quannah Chasinghorse is changing the face of modeling—undoubtedly for the better. A member of the Hän Gwich'in and Sicangu Oglala Lakota tribes, she is a proud advocate for Indigenous land and climate preservation.

"I grew my platform through my advocacy work, through being a land and water protector and showing up. That's what got me attention and started my career. Being able to live my dream and continue that important work is all I could ever ask for."

Chasinghorse spent part of her early childhood living in Mongolia, falling in love with modeling watching the fashion channel because it didn't require understanding the local language.

"I was obsessed with watching runway shows on television—Dior, Chanel, Prada—and I was always posing for pictures." But due to a lack of representation in the industry, she said, "It was really hard for me to feel like I had the potential to be a model."

Her family later settled in Fairbanks, Alaska, and Chasinghorse began to learn more about her culture.

"At fourteen, I was the first Indigenous girl [in my tribe] that young to receive a traditional tattoo in probably over a century. I waited until I was educated enough that I could speak on it and know what I was talking about. Before then, starting at twelve, I would just draw it on with [eyeliner]."

Now, she has walked the runways for Gucci, Chloé, Savage x Fenty, and Prabal Gurung and starred in campaigns for Calvin Klein, DKNY, and Mackage.

"The industry has, in the past, appropriated Native American traditions and art, never recognizing where those designs came from. So it's really important for me to uplift my own people."

In 2021, Chasinghorse became the first Indigenous woman to walk the runway for Chanel: "[It made] me feel comfortable, seen, and beautiful!"

Photographed for *Elle* magazine, Chasinghorse dazzled in a Celine bodysuit and Bulgari necklace, a Dolce & Gabbana blazer and bustier, Miu Miu jeans, and plenty of Cartier jewelry. She's also posed for *Vogue* magazine, stunning in Givenchy, Valentino, Victoria Beckham, and Louis Vuitton.

When she's not donning high fashion looks for photo shoots and runways, Chasinghorse's own wardrobe celebrates Indigenous labels, including Jamie Okuma, Thunder Voice Hat Co., and Bethany Yellowtail.

"We're starting to see more Indigenous people being uplifted and included, and it's amazing to be a part of it."

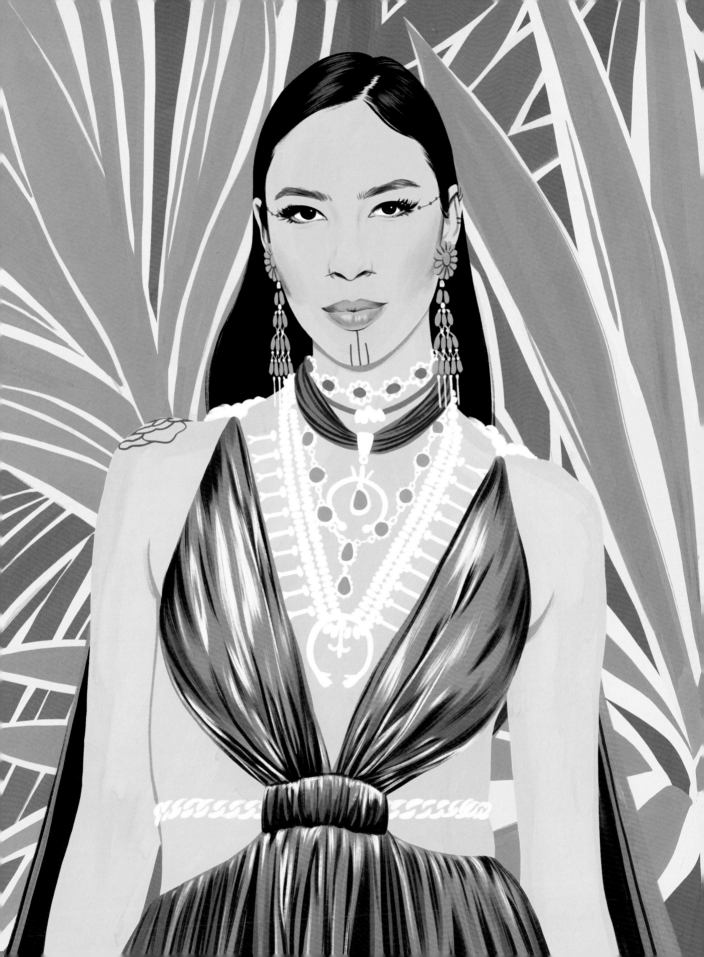

Emma Corrin

"It's hard to be discovering something in yourself at the same time you're navigating an industry that demands a lot of you, in terms of knowing who you are."

At twenty-six years old, Emma Corrin has already won a Golden Globe for playing one of the most iconic women of all time, the late, beloved Princess Diana. And much like the stylish character they portrayed in *The Crown*, Corrin has a distinct presence on the red carpet, albeit much more avant-garde than the formal royal was ever allowed.

As a child, Corrin loved playing outdoors, building forts, and making the most of summers at their home in Kent. When they were about nine years old, they took an interest in dance and theater, playing Toad of Toad Hall in *The Wind in the Willows*.

"Afterwards, someone's mum came up to me and very innocuously said, 'You were great, honey. Have you thought about being an actor?' I think that planted a seed, and there was nothing else I ever really wanted to do after that. Marine biology was in contention for a little bit, but there was never a great chance of that happening."

With the award-winning role of Diana under their belt, Corrin's career has every avenue to grow and flourish, and their presence is already well-known, from the red carpet to high-fashion photo spreads.

The first nonbinary person to grace the cover of *Vogue*, Corrin brought plenty of style to the shoot, sporting Louis Vuitton, Marin, and Comme des Garçons dresses, Proenza

Schouler shoes, and plenty of Cartier jewelry and Miu Miu items, both of which they represent as a brand ambassador.

"My Miu Miu family is incredible, and I love the stuff they're doing. The recent collection is so fluid and really boundary pushing. That's something I really love, and I'm really grateful to be involved."

Frequently collaborating with stylist Harry Lambert, Corrin often favors designers Loewe, Marco Ribeiro, and Charlotte Knowles.

"[Lambert] is a really close friend, and we know each other very well. There's so much trust here, and he loves pushing me out of my comfort zone, and I sort of go where it leads me. But also, he knows me very well. And that's pretty relaxing."

At the *My Policeman* premiere, Corrin wore an eye-catching dress by British designer JW Anderson, which portrayed a fish in a plastic bag with asymmetric shoulders, a genuine wonder to trick the eye. They show no fear in front of the camera, never boxing themselves into one genre or another. Instead, Corrin has opted to take risks and explore how they want to express themselves sartorially.

"I'm kind of starting to build a collection that I really enjoy," Corrin said. "I like investing in pieces, I suppose, a bit like you would in art."

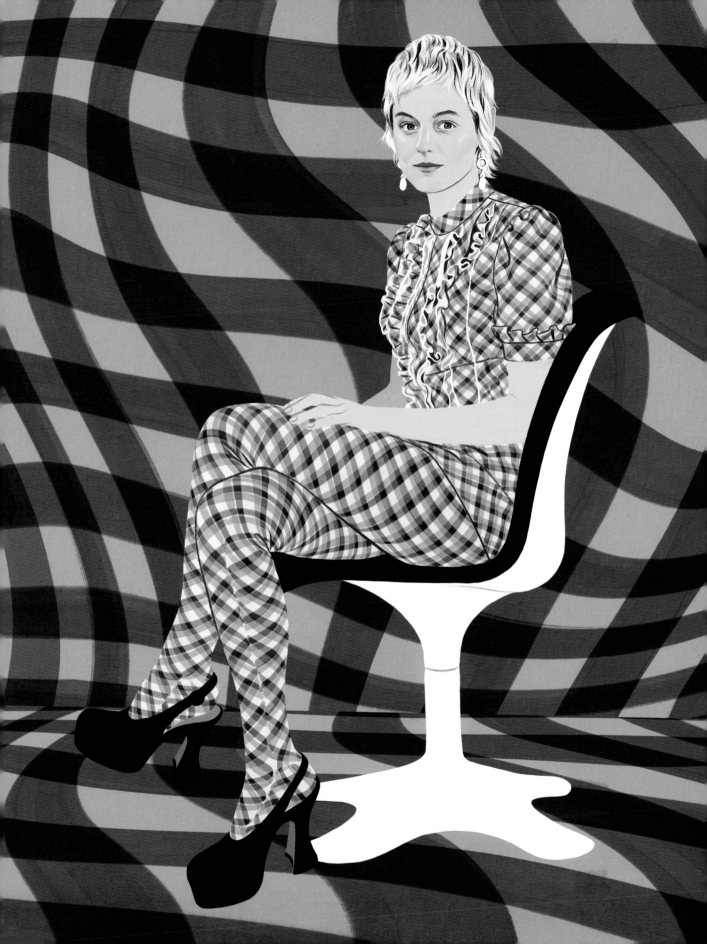

Dapper Dan

"Fashion is just a vehicle. It's an instrument I'm using to express something much deeper, to hopefully effect change. That's what this is all about."

Harlem couturier Daniel Day, aka Dapper Dan (the nickname was gifted to him from the saxophonist who had it before), opened his first Harlem boutique in 1982, sampling logos like Gucci, Louis Vuitton, and Fendi, and transforming them into luxury patterned looks in flamboyant and unexpected ways.

"I deconstructed the brands down to the essence of their power, which was the logo crest, and reconstructed that power in a new context. The names and the crests signified wealth, respect, and prestige. My customers wanted to buy into that power, and that was what I was offering."

Back then, his jackets and tracksuits were worn by Big Daddy Kane and LL Cool J; Salt-N-Pepa wore coordinating leather pieces from his studio. Finding the perfect audience for his creations, Dan helped define the era of rapper chic. But before he became a designer to the stars, Dan made his way via gambling, a profession and education he began at the age of thirteen.

"I was involved in the paper game, and I made a lot of money, but I didn't want to be associated with the street anymore. I knew I liked clothes, and I knew all the hustlers in Harlem, so I said, 'I'm gonna open a clothes store and cater to all of those people.' I didn't know that I wasn't going to be able to buy from wholesalers and stuff."

He taught himself about furs and started selling them ("Everybody in Harlem loved furs, but they didn't know anything about them"), and then he learned about textile printing. "I came up with a chemical that I could put on leather, and it would last. I used to keep the cans secret so nobody knew what kind of ink I was using. . . . Now I can produce images on leather through computer technology."

Yet, he was forced to close up shop in 1992 when lawyers for the logos' brands came knocking. Although forced underground, Dan never stopped designing. In fact, Nelly wore a Dapper Dan design to the 2001 Grammy Awards. "That was one of the first outfits I made using digital prints. I would create different treatments to enhance logos, because what I learned when I opened the store was that a logo is like a diamond. A diamond signals you have money. A logo had the same effect."

Ironically, in 2017, Gucci created a mink bomber jacket with the double G monogram, which was a direct copy of one of Dan's designs from 1989. As the luxury brands were now copying him, this ultimately was resolved and in 2018 led to an official collaboration with Gucci and then creative director Alessandro Michele.

Since his reemergence into the public eye, Dan has collaborated with Puma, dressed stars like Salma Hayek, Beyoncé, and Megan Thee Stallion, and teamed up with Gap for their spring/summer 2022 campaign, celebrating the importance of individuality.

"What I wanted to do is de-stigmatize the hoodie. That's why you see me with a hoodie on with an ascot. All of us in the culture wear hoodies. All of us in the culture are not the same."

Nowadays, he relishes collaboration opportunities as a chance to share his contributions.

"I want to elevate this. I want to give it more color. . . . Let's touch on my thing about logomania, but the main thing I want to do is elevate the brand. I wanna take the brand and make it more luxurious. It's what I always did."

Of course, the logos still play a major part in his design aesthetic.

"Can we escape [logomania] ever? I don't think so. Logomania says, 'I have arrived, this is it. Don't you see my Gs, don't you see my Fs, don't you see my logo?' That's what it says. And as the culture expands and people move up the social ladder, they want everybody to know, 'I'm up here now.'"

In 2019, he released a memoir, *Dapper Dan: Made in Harlem*, in that same year dressing the likes of Ashley Graham, Regina Hall, and Karlie Kloss for the annual Met Gala.

"The attention I give my customers when they come into the shop isn't just a way to make people feel appreciated so they can keep coming back. Listening closely is the key to my creativity. My designs are a response to the energy a client gives me. I thrive off that one-on-one exchange. I don't think of myself as an artist or even as a couturier; I'm just using fashion to tell their stories."

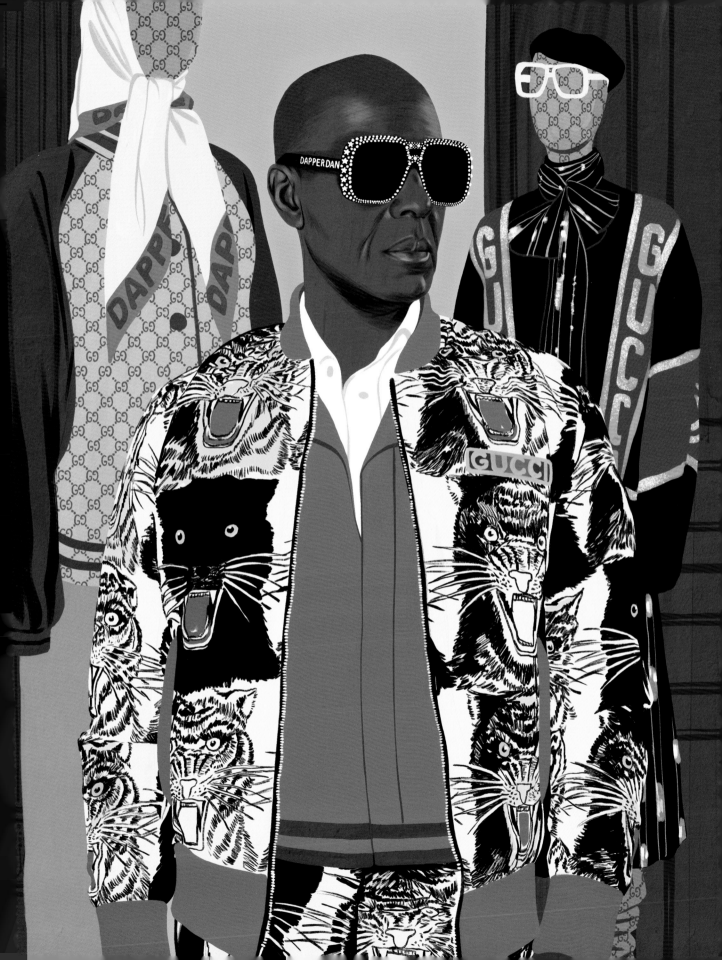

Billie Eilish

"Dress how you want, act how you want, talk how you want, be how you want. That's all I've ever said. It's just being open to new things and not letting people ruin it for you."

The accomplishments of twenty-year-old Billie Eilish are enough to fill the résumé of a musician three times her age. Eilish recorded her 2019 debut album at home, became the youngest artist to record a James Bond theme, and in 2022 broke two Guinness World Records (most consecutive Grammy nominations for Record of the Year as a female and youngest person to win an Oscar, Golden Globe, and Grammy for a single track, "No Time to Die").

And although music is her profession—and has been since age thirteen with the release of breakout song "Ocean Eyes" (recorded with brother Finneas O'Connell)—fashion has played an essential role in her life even longer.

"Since I can remember, [fashion] has been how I convey my feelings, how I feel about myself, and my mood. It's really like a security blanket, and I can't remember when it wasn't."

Eilish has frequently stepped out in baggy clothes (which she has attributed to teenage insecurity), black-and-green hair, and a swagger that exudes a maturity well beyond her years.

"No matter what you do, it's wrong and right. Wearing baggy clothes, nobody is attracted to me, I feel incredibly unlovable and unsexy and not beautiful, and people shame you for not being feminine enough."

But looking back, she can appreciate her evolution and her past looks as a moment in time.

"I would say that when I was, like, fifteen and sixteen, when I knew that what I was wearing was exactly how I wanted to present myself and be seen and identify as, and no matter how crazy it looks to me now, I will always respect that girl and respect that feeling of power and this is what I'm presenting myself as and that's it, period."

On the red carpet she's appeared in Marc Jacobs, Simone Rocha jewelry, a Prada cropped puffer, a loose Gucci suit, Sailor Moon print, and neon Louis Vuitton from head to toe. She's done grandma chic in Chanel and all-black gothic in Rick Owens. At the 2020 Met Gala, Eilish sported an Oscar de la Renta princess dress. She's also collaborated with Nike on multiple shoes and a line of clothing and accessories for H&M.

"When I meet people who don't care about clothing— what they wear and how they wear it—it boggles my mind."

Eilish went full blonde curvy pin-up in 2021, appearing in *British Vogue* in corsets and flowing silks—a transformation that stunned fans and ruffled a few feathers.

"If you're about body positivity, why would you wear a corset? Why wouldn't you show your actual body? My thing is that I can do whatever I want. It's all about what makes you feel good."

But after the fact, she admitted that the look was a bit of an identity crisis—one that she nonetheless pulled off flawlessly to the outside world.

"Before that, I was one kind of person and wore a certain type of clothes and made a certain type of music . . . and that haunted me, as people only thought of me in one dimension and I didn't like that. I felt pretty trapped in the persona that people had of me, and then I changed it completely to fuck with everyone. I wanted to have range and to feel desirable, and to feel feminine and masculine— and I wanted to prove that to myself, too. Now I finally feel comfortable in the person I actually am and being all of those things at once."

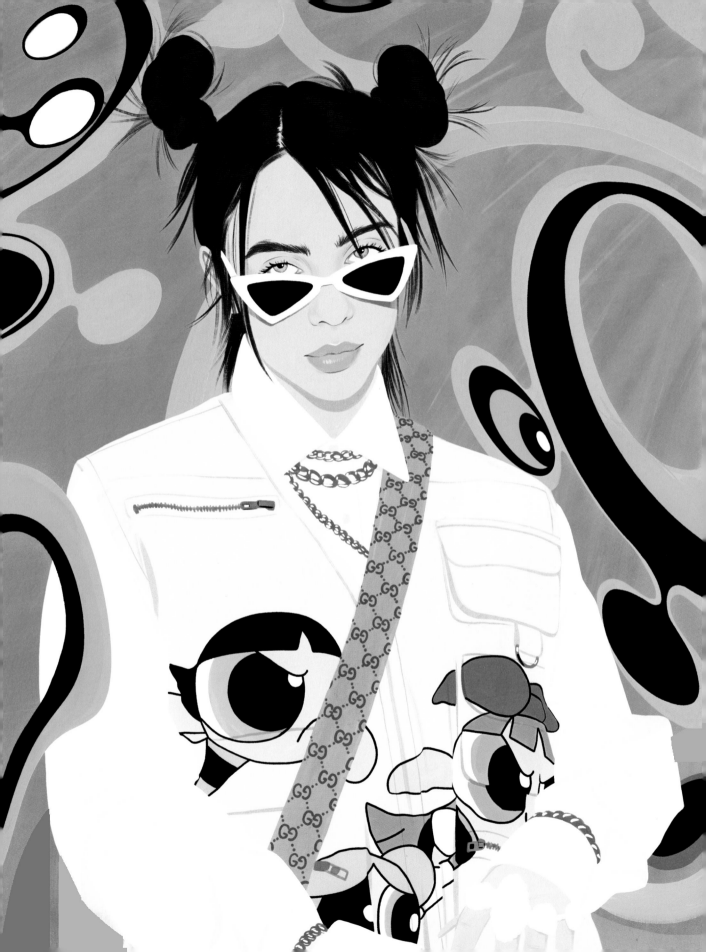

Paloma Elsesser

"I do identify as plus-size. I can't walk into any store and have everything fit me, so I have to be a little more creative."

Paloma Elsesser grew up surrounded by family. "I identify my upbringing as 'hippie poor.' Both of my parents were musicians, and my mom was a teacher and writer. I grew up with Black Methodist grandparents, and we were all in one household."

After high school, she moved to New York to attend the New School for literature and psychology. "Modeling was never on my radar—at best, I thought maybe I could do some personality work. I used to watch MTV and think about how sick it was to be a VJ."

At a friend's suggestion, she sought out modeling agencies but said she didn't know what to wear or how to move in front of the camera. "I didn't fit into what the archetypal plus-size woman was in the industry. What were they going to do with me?"

Eventually, however, legendary British makeup artist Pat McGrath contacted Elsesser on Instagram, drafting her to promote her new brand.

"To see myself as this beautiful, glamorous creature was affirming, and there was something specifically comforting in having a plus-size Black woman there being supportive. I felt so seen." McGrath saw a once-in-a-lifetime discovery, comparing Elsesser to Lena Horne or Rita Hayworth.

Later signing with IMG and Huxley, Elsesser has walked for Lanvin and Alexander McQueen in Paris; appeared in New York for Eckhaus Latta and Savage X Fenty; and become one of the first-ever plus-sized models to walk in a Fendi show. She's starred in campaigns for Salvatore Ferragamo, Nike, Glossier, Fenty Beauty, and Ugg.

"When I came into fashion there was a divide between the plus-size industry and high fashion, and I think there was a vacancy for a person like me. I didn't come here to be the only one—and I can only be myself—but I came in guns blazing."

Elsesser has also served as the face of Coach's Originals Go Their Own Way campaign. "My first interaction with Coach was a Coach bag. I found an authentic leather one at a consignment store when I was in middle school, it was like a saddle bag. Then there was the era where the *it* shoe was Coach's monogram sneakers."

She's flaunted Comme des Garçons, Adidas, Maximilian, Givenchy, Miu Miu, and Jean Paul Gaultier in *i-D* magazine; appeared on the cover of *WSJ. Magazine*, styled by Julia Sarr-Jamois; and graced the cover of *Vogue*, wearing Michael Kors and Schiaparelli, photographed by none other than Annie Leibovitz herself.

"It was a real moment in my career. I have critiques of that magazine, and I have critiques of fashion in general, but I can also simultaneously be proud of myself and understand that was an insane moment."

There's still work to do in the industry, and Elsesser is proud and happy to do her part.

"I've learned so much about myself and the next evolution of what I'd like my career to be. It's an immense honor even to be able to do this—but it also feels like something that should have existed long before I started."

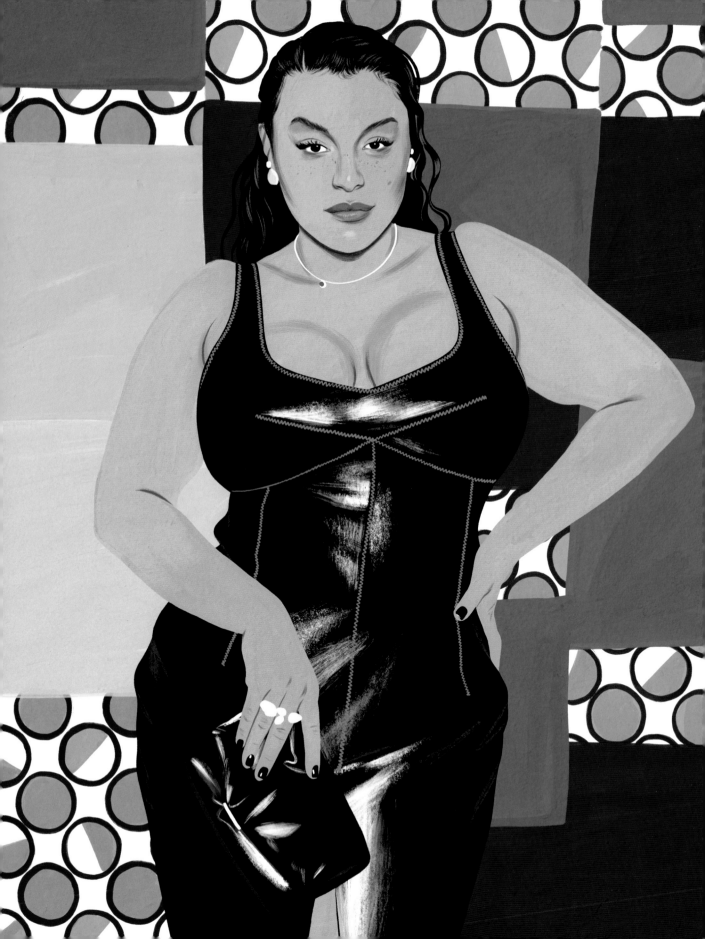

Ella Emhoff

"I was pretty surprised when everything with IMG was happening because when I was younger, I never saw that as being part of my timeline. As someone who, like a lot of young girls out there, had self-confidence issues, it is intimidating and scary to go into this world that is hyper-focused on you and the body."

Before the 2021 presidential inauguration, Ella Emhoff was mainly a student at Parsons School of Design, a fairly new New Yorker with a family connection to politics. But thanks to a bejeweled Miu Miu coat she wore to attend that historic event for her stepmother, Vice President Kamala Harris, Emhoff's life changed overnight, suddenly receiving recognition as a fresh face in fashion and only days later signing an IMG Models contract.

"I think modeling now is not *just* about modeling, but it's about creating space for people who do other things, whether it be art, activism, writing, any type of creation. And I get really excited when I'm able to do things and work with brands that actually let me not only be the model but actually share my own thoughts and have [conversations] like this where I can talk about sustainability and activism in general."

Since the inauguration, the twenty-three-year-old has been soaking up a bevy of new experiences and using her newfound fame to champion causes dear to her heart, including collaborating with Stella McCartney.

"She's one of the biggest leaders in this push for sustainability. She was on the ground first doing it, and she's not only creating sustainable products but new materials [like mushroom leather]."

Emhoff's street style is quirky and unique, sporting round, owlish glasses, giant nubby sweaters worn as minidresses, and clunky work boots. She has a "funky haircut" and about eighteen "weird tattoos."

"[It's] so strange, but it also makes me feel really good, because I was able to stick with my true instincts when it came to style, and it actually paid off! But if I had to describe my style right now, it's not even a way of dressing. It's just wearing clothes that you feel good in, not really being influenced by what other people want you to be wearing.

And also, not getting boxed in by what you used to wear, or what people *think* you would be wearing. Lately, I've been thinking, 'Wait, maybe I *do* want to wear a giant skirt with a tiny little top! Who knew?' Because it's not the actual clothes you're wearing. It's the confidence you have, and the ability to live your life, in those clothes."

Embarking on her new modeling career, Emhoff first walked a virtual runway show for Proenza Schouler, and then a semi-live walk for Balenciaga. She's appeared on Miu Miu's runway, worn Dior in *Vanity Fair*, and served as the face of Adidas by Stella McCartney. And don't forget hanging with fellow fashion icon Timothée Chalamet at the Met Gala, where she dressed in Stella McCartney.

"Stella's really good at pushing for industry change, and also, her style is *great*. It's fun but also sophisticated. You actually want to wear it, not just because it's sustainable, but because it's cool."

The cosmic shift in Emhoff's life certainly came as a bit of a surprise. "Growing up, I never saw myself as someone stylish, at all! Obviously, I loved fashion and cared a lot about it. But I was really into doing my own thing and being really comfortable in my own body, you know? I never saw myself as a 'fashion person.'"

Now a graduate of Parsons, Emhoff has also had the opportunity to create a small knitwear collection with Batsheva Hay.

"A lot of our personal design preferences are aligned. Having the bright colors I love mixed with her traditional silhouettes; it was kind of the perfect melding of styles."

Down the line, Emhoff would like to create an eponymous collection all her own.

"I want to see guys, girls, people, everyone wearing striped colorful pants or my dresses. I think that'd be great."

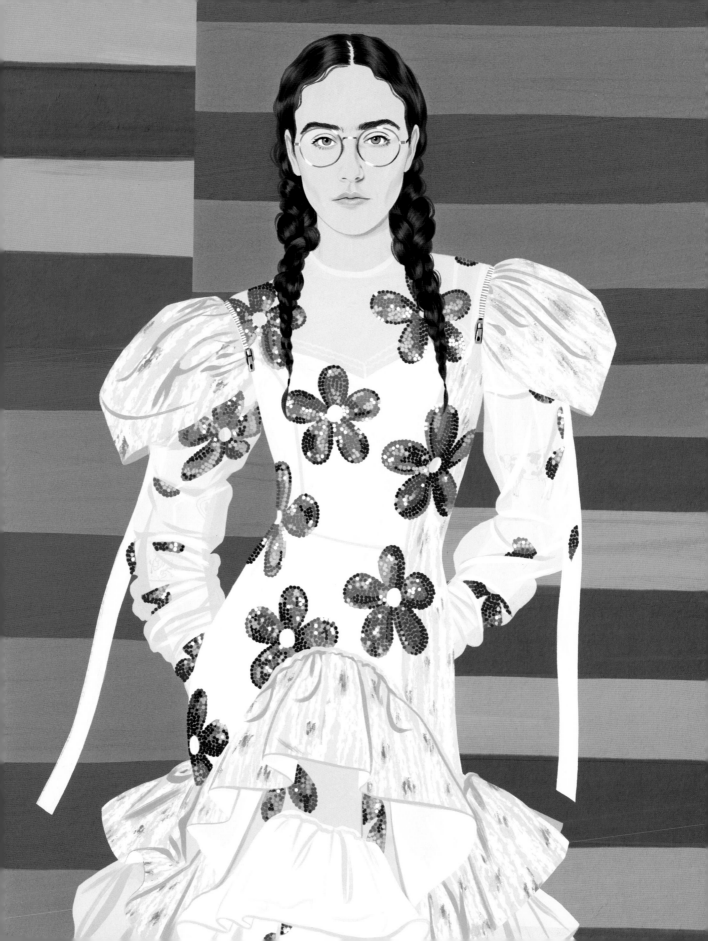

Jeff Goldblum

"I don't think taste is ever defined by good taste. There's only personal taste, which has sort of guided my thinking. You should look inside and accept your personal taste, which means anything is includible, including what might be thought of as ugly, low class, or out of the current realm of popularity."

Everyone's favorite *Jurassic Park* scene stealer has been turning heads for decades with his performances in *The Fly*, *Independence Day*, and several Wes Anderson projects. And off set, you can find Jeff Goldblum making an impression in bold-patterned shirts or zebra-print pants.

It's an interest he's cultivated from an early age, since a summer drama camp sparked his attraction to acting. ("I'll be darned if it wasn't the best summer of my life. I was just in love with life and my prospects and my future and my potential. I was on fire. That's when I started to write on my steamy shower door, 'Please, God, let me be an actor.'")

"My whole life I've had an aesthetic appetite. Early on, I had a flair for drawing and took special art classes in Pittsburgh. On more than one occasion, I drew various collar and tie combinations. Around that time, I went with my mom to Gimbels or Horne's department store, and picked out this Nehru jacket that I'd seen Sammy Davis Jr. or someone wearing on the Johnny Carson show. I got that and a turtleneck and maybe some medallions. That was right at the age I was watching James Bond."

Several years ago, on a *GQ* photo shoot, he met stylist Andrew Vottero, and deciding to take his wardrobe more seriously, Goldblum enlisted the help of Vottero to revamp his look.

"I said, 'I would sure enjoy it if you came over and told me which jeans to throw away.' And that's how we started working together. In the years since, we got rid of everything that was in my closet back then—maybe I have one or two things left. Everything has been replaced and built upon, and we've collaborated on all kinds of projects, including movies here and there. But as a student of acting, I've always been interested in how clothes make you feel, and how they create your so-called character. I've also been doing jazz shows

for a few decades now, so I also enjoy the impact of clothes when I present myself as myself."

Vottero has been collaborating with Goldblum ever since.

"I think I bring something to it, and he's definitely the expert. I'm always bright-eyed and bushy tailed when we try stuff on. But honestly, I don't know how other people do it. There's so much out there, and without a guide, I don't know how you figure it out."

More recently, the towering, six-foot-four Goldblum slunk down the Prada runway for the 2022 menswear presentation.

"Geez, what a fun opportunity. I'd never done that before. In fact, I've only attended two other fashion shows in my entire life. I went to an Armani show in Milan, and they seated me between Claudia Cardinale and Sophia Loren. The only other time was when Raf Simons did a collaboration with Calvin Klein. They outfitted me in a nice little satin cowboy-inspired thing, which I enjoyed."

Goldblum is a fan of Acne Studios jeans, a Saint Laurent or Tom Ford suit, and hats by Gunner Foxx or Nick Fouquet.

"I've made a couple of purchases of shoes that have been verrrry important for me in the last period of time. I went to Yves Saint Laurent—that's one of the places we wound up feeling right about—and I got some spectator shoes that I've worn a lot for my jazz gigs."

He's gone through a black-and-white phase, followed by a hankering for color and prints, and the sky's the limit on the next chapter of his style evolution.

"It's fluid and ever on the move. I'm given to this sort of nincompoopery where one day I say, 'Eureka, that's it. I found myself.' Sure enough, the next day or the next week, I'll go, 'Well, that's enough for that. What can I do next? What interests me now?'"

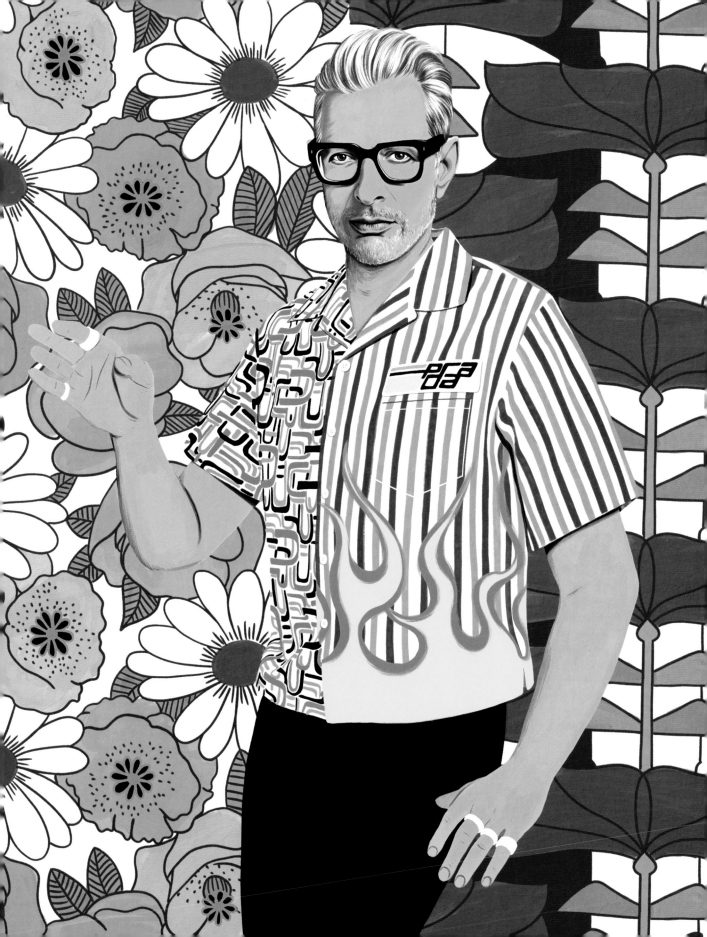

Peggy Guggenheim

"I collected little wax models and dressed them in the most fashionable of clothes, which I created and executed myself. This was inspired by the fact that we were summering in Trouville where all the ladies and the courtesans were so chic."

Peggy Guggenheim experienced an immense amount of hardship in her life, and although many doubted her efforts, including her own family members, she lived a fascinating life and created a lasting legacy in the form of the Peggy Guggenheim Collection.

"I've always been considered the enfant terrible of the family. I guess they thought I was a bit of a black sheep, and would never do anything that was ever any good. I think I surprised them."

She began collecting Surrealist, Cubist, and Abstract works in 1938 (when neither the Louvre nor her uncle's Guggenheim museum thought they were worth anything), opening the Guggenheim Jeune Gallery in London that same year, and the Art of This Century gallery in 1941, with one of the most important contemporary collections in the Western world. She smuggled her art collection out of England during World War II, and after the war, purchased a Venetian palazzo to display it. Guggenheim is known for promoting American artists, including Robert Motherwell, Mark Rothko, and Jackson Pollock.

"Jackson Pollock was working as a handyman in my uncle's museum when he was brought to my attention. We gave him his first show and later I commissioned a large mural for the entrance hallways of my duplex apartment. It was important and exciting because there was really no American movement in art at the time, which I think they needed very badly."

Much like her impeccable taste in artwork, Guggenheim had a flair for fashion, in the mid-1920s appearing in portraits by Man Ray dressed in Paul Poiret with a headdress by Vera Stravinsky. She was also close friends with Elsa Schiaperelli and was photographed wearing an iconic cellophane-wrapped gown. Later in life, Guggenheim commissioned a stunning pair of butterfly sunglasses by Edward Melcarth, which she could be seen wearing along the Venice canals as the last private owner of a Venetian gondola.

On one particular occasion, Guggenheim wore one Tanguy earring and one Alexander Calder earring to a gallery opening to challenge the conventional separation of Surrealism and abstraction.

Her personal collection included an abundance of jewelry, tricorn hats, and a variety of furs; after settling in her Venetian palazzo, Guggenheim invested in two chic outfits: one by Fortuny and another by textile designer Ken Scott.

During her life, Guggenheim penned a tell-all memoir, *Out of this Century: Confessions of an Art Addict*, which revealed many of her most-personal exploits, shedding light on an oftentimes mysterious persona.

Self-doubt and demands by her husband complicated her relationship with fashion. She wrote in the memoir, "[Florenz] liked me to dress extravagantly and he took me to Paul Poiret and made me buy elegant clothes, but my fast advancing waistline was not very attractive and I did not look very chic in these wonderful costumes."

But there are many other instances where she seems to appreciate the role of clothing in her life: "I was wearing an elegant costume trimmed with kolinsky fur that I had designed for myself," and, "Though I was only a clerk, I swept into the bookshop daily, highly perfumed and wearing little pearls and a magnificent taupe coat."

After a lifetime of collecting, Guggenheim's collection was finally recognized by her uncle's museum three years before her death. The Peggy Guggenheim Collection was signed over to the Solomon R. Guggenheim Foundation in 1976.

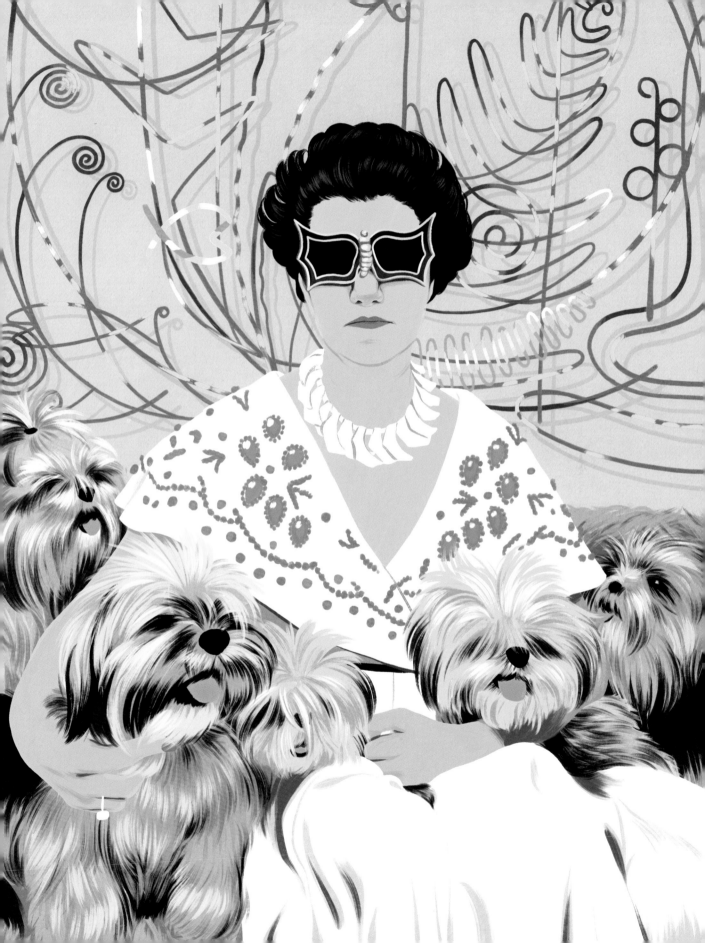

Jeremy O. Harris

"American fashion is Black fashion. I think part of expanding the American fashion lexicon has to be to celebrate Blackness and how it intersects with our culture at large. We can't only think about the faces who have been able to run major fashion companies or been privileged to design for [fashion houses], but rather the people from whom they have taken so many of their inspirations."

At thirty-three years old, Jeremy O. Harris has already written a play (*Slave Play*) that earned a record-breaking twelve Tony Award nominations, another play (*Daddy*) that secured him a spot at Yale, as well as a feature film, *Zola* (he cowrote with Janicza Bravo). Harris is an advisor and coproducer on *Euphoria*, and has two other HBO shows in the works, one based on his drama school days at Yale.

His success has provided other impressive opportunities—acting roles on *Emily in Paris* and *Gossip Girl*, and a Gucci sponsorship.

"[Gucci] is more about personal creativity than it is about a brand impressing upon you. I am a creative person and I think that when I'm wearing Gucci, I feel free to be my full self and not like I'm wearing some costume that articulates that I'm someone outside of the person I've been my whole life."

He sported plenty of Gucci in a shoot for *Highsnobiety*; guest edited *Interview* magazine's September 2021 issue; and attended the 2021 Met Gala in custom Tommy Hilfiger inspired by the later singer Aaliyah.

"When I was a child, Tommy Hilfiger created this moment of Black youth culture—of music culture—that completely shifted what I thought was cool. And it was centered around Aaliyah, who I loved so much."

Harris has also created a twenty-five piece capsule collection with SSENSE, which featured an ankle-length plaid skirt and boxy button-downs. "I wanted to make something that was really accessible, super easy, that felt like the clothes a writer would wear while at work, whether that's at a laptop or at a dinner party."

One hundred percent of the proceeds from the collection are donated to the Pet Project Grant at the Bushwick Starr to help out-of-work playwrights.

Photographed for *10 Men* magazine, Harris wore 1970s-inspired suits from the Gucci Ha Ha Ha collection, inspired by the friendship between Alessandro Michele and Harry Styles.

"These clothes all fit me perfectly. I think it's easy because Harry and I are friends, and we have very similar aesthetics. When Ali reads this, he will see I'm ready to get in. I'm ready to do, you know, the JOH X AM collab. JOHAM might be what it's called, or JAM maybe? Maybe we call it just JAM."

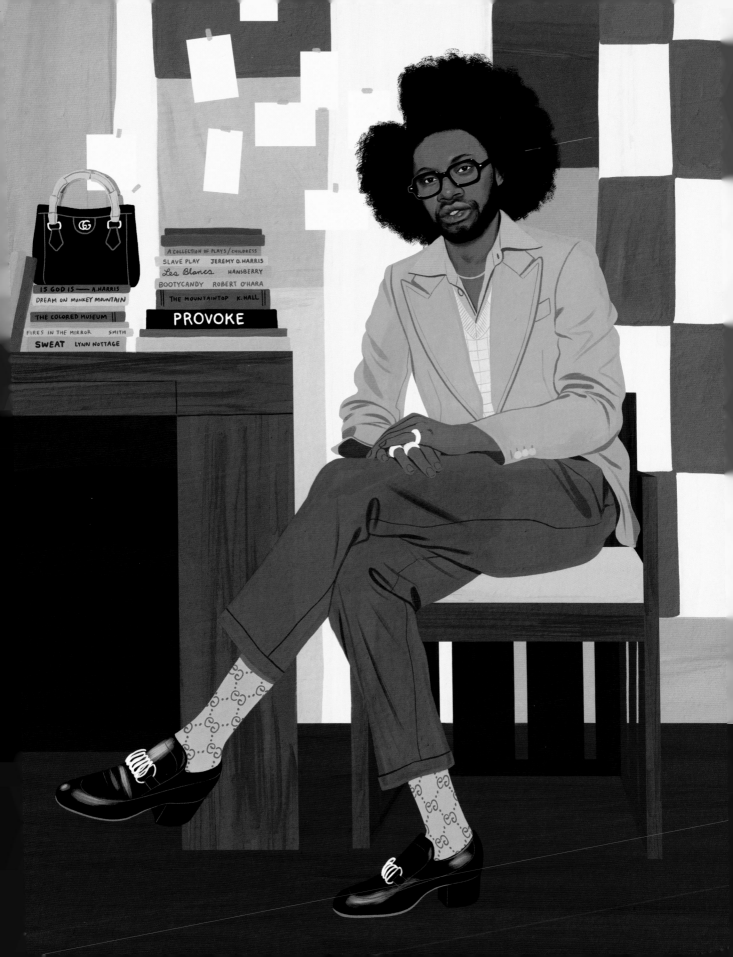

Edith Head

*"Be sure it doesn't look like something you can buy in a store.
Be sure that people will gasp when they see it."*

"I didn't have what you would call an artistic or cultural background. We lived in the desert and we had burros and jackrabbits and things like that."

Beginning her career as a French teacher, Edith Head (born in 1897 in California) eventually answered an ad for a costume sketch artist for Paramount Pictures, using a friend's drawings to land the gig. Her secret was quickly discovered, but somehow she was hired anyway, and her new career began.

Head remained at Paramount for the next forty-three years (becoming the first female chief costume designer in 1938), until joining Universal in 1967—there she had her own cottage.

Working on as many as one thousand films, Head's credits include *Funny Face*, *Sabrina*, *Roman Holiday*, *All About Eve*, and *To Catch a Thief*. As a result, she had the honor (and vice versa) of styling some of Hollywood's most glamorous names, including Audrey Hepburn, Elizabeth Taylor, and Sophia Loren. She designed Grace Kelly's stunning costumes in *Rear Window*, outfitted Rosemary Clooney and Bing Crosby in *White Christmas*, and won her first Oscar for her work on *The Heiress* in 1949. With her eight total wins (and thirty-five nominations), she still holds the record for most Oscar wins (her "children") by a woman in any category.

Head found success in pleasing the stars she worked with rather than creating the most original pieces. "I've been a confirmed fence-sitter. That's why I've been around so long."

Few notable females of old Hollywood were denied the privilege of working with Head. Marlene Dietrich, Rita Hayworth, Bette Davis, Ingrid Berman, Mae West, Joan Crawford, and Marilyn Monroe all wore her designs.

But she did not work with women exclusively. After winning her Oscar for *The Sting*, she said, "It was the first time that the costume design Oscar went to a picture with no female star"—proving the diversity/flexibility of her work was already widely recognized throughout the industry.

As a costume designer, Head set out "to change people into something they weren't—it was a cross between camouflage and magic. . . . Then, a designer was as important as a star. Dress was part of the selling of a picture." She once said, "There isn't anyone I can't make over."

Head showcased her own iconic look: curled bangs, bun, tortoise-shell glasses, and two-piece suit; she was barely five feet tall. "Little Edith in dark glasses and the beige suit. That's how I've survived."

Throughout her career, Head published two books, *The Dress Doctor* and *How to Dress for Success*, appeared on the quiz show *You Bet Your Life*, and designed uniforms for Pan American World Airways and United Nations tour guides. She wrote articles for *Photoplay* magazine and appeared as a regular guest on Art Linkletter's *House Party*.

Looking back on her career later in life, Head remembered the thirties fondly: when "the star was a star . . . [and] she wore real fur, real jewels."

Head passed away in 1981 at the age of eighty-three, leaving an enormous legacy that lives on with every rewatch of the countless classic films she styled. "You gotta give 'em what they want, kid. If you don't, they'll find somebody who will."

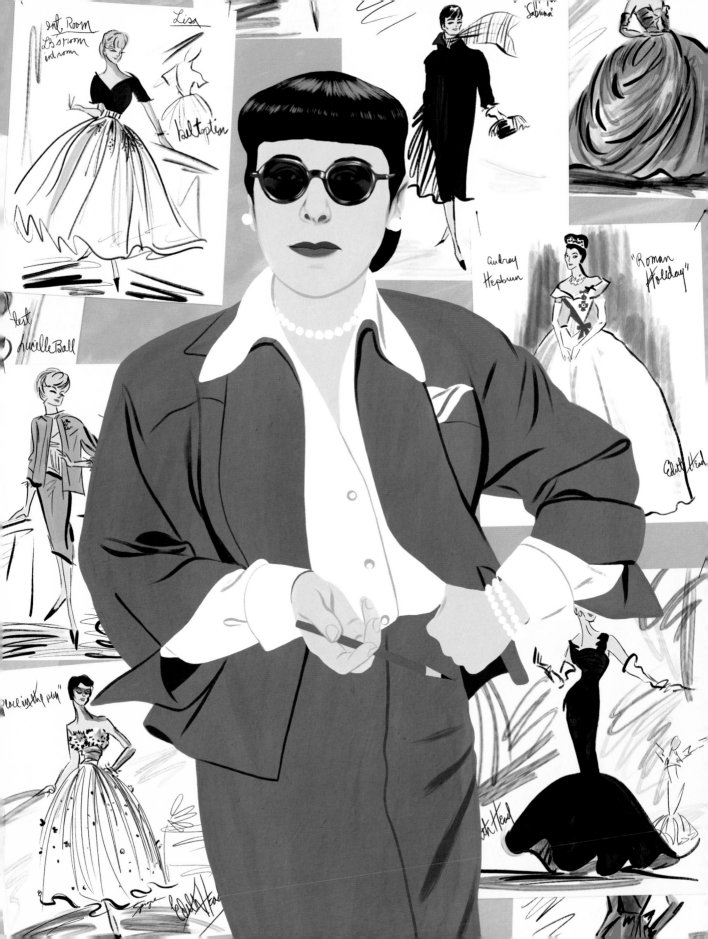

Audrey Hepburn

"Elegance is the only beauty that never fades."

Audrey Hepburn possessed a style and grace that has proven timeless and lasting since she first starred in *Roman Holiday* in 1953, a role that would earn her an Academy Award.

But it was her 1954 film, *Sabrina*, which solidified her beginnings as a fashion icon. It was her first film collaboration with French designer Hubert de Givenchy, who designed costumes for the film as well as many more of her projects to come, including *Charade*, *How to Steal a Million*, and *Love in the Afternoon*. As a favor, Hepburn also served as the face of his fragrance, Interdit.

"Givenchy's clothes are the only ones I feel myself in. He is more than a designer; he is a creator of personality."

Hepburn grew up in Belgium and the Netherlands during World War II, dancing in underground theater performances to raise money for the resistance. Her prima ballerina dreams would not come to fruition, but a chance meeting with Colette in Monte Carlo led to Hepburn's role in the live production of *Gigi*.

As her film career developed, Hepburn began amassing a collection of stunning looks that would inspire designers and fashion lovers for decades to come, whether it be the strapless gown with black embroidery she wore in *Sabrina*, the mini dress with head scarf she donned for her wedding to Andrea Dotti in 1969, or the little black dress to end all little black dresses in *Breakfast at Tiffany's*. Hepburn could impress in black capris and flats or a bejeweled ball gown with matching tiara in *My Fair Lady*.

"For beautiful eyes, look for the good in others; for beautiful lips, speak only words of kindness; and for poise, walk with the knowledge that you are never alone."

Although she appeared in fewer than thirty films during her career (she eventually pursued privacy and charity work instead), Hepburn's legacy as one of the greatest stars of all time has a firm and immovable foundation.

"I more or less quit movies to stay home. . . . I don't want to be made to sound virtuous. It was a very knowing and, if you like, selfish decision. It's what made me happiest, to stay home with my children. It was not a sacrifice because I thought I should take care of my children."

As her children grew older, Hepburn signed on as an ambassador for UNICEF, giving back to an organization that meant so much to her as a child.

"The first thing I remember after our liberation in Holland was the Red Cross and UNICEF coming in and filling all the empty buildings that they could find with food, and clothing, and medication. I was suffering from a rather high degree of malnutrition when the war ended, so God knows I know the value of food."

Although she passed away at only sixty-three, it seems unimaginable that Hepburn's legacy will ever be forgotten. "The most important thing is to enjoy your life. To be happy. It's all that matters."

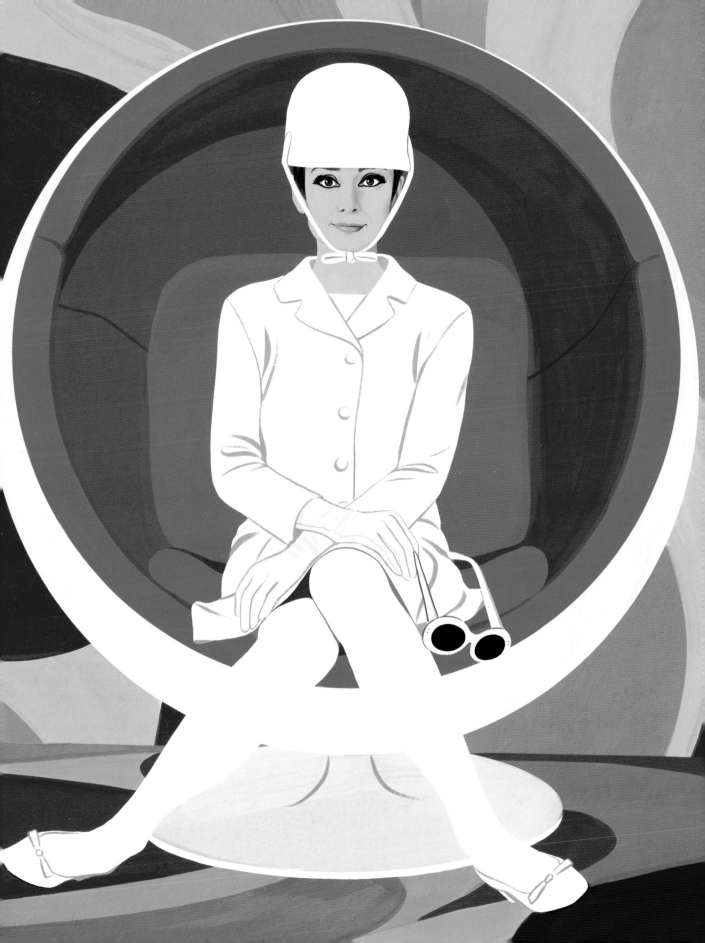

Elton John

"I loved my success in the early days, and I loved dressing up, and I loved clothes."

What's there to say about Elton John that hasn't already been said? The Rocket Man himself has enjoyed the kind of longevity in the music industry that few can boast, and he's never failed to dress to impress, embracing color, humor, and experimentation with complete abandon.

"Throughout my career, clothes have been so important. Without that process of dressing up and looking different and having fun, I would never have been the artist that I became, never."

John has played piano since childhood, and after forming a blues band in 1962, he released his debut solo album, *Empty Sky*, in 1969. The rest is history, and he's made plenty of it, having sold more than 300 million records worldwide and earned five Grammy Awards, two Academy Awards, and the Kennedy Center Honor (among many other accolades).

His custom beaded Dodgers baseball uniform alone may be plenty to earn him a fond place in the hearts of fashion lovers, but his collection of fantastic ensembles—featuring plenty of feathers, oversized glasses, and colorful wigs—is enough to fill Wembley Stadium, a venue he sold out in 1975.

"I sat at a piano. . . . I don't move around the stage. I've got to attract attention somehow. And that was the whole point with me. I didn't want to repeat myself and I wanted, as I got more and more famous, to become more outrageous."

He's worked with countless iconic designers, including Gucci, Versace (he was close friends with Gianni Versace), Sandy Powell, Annie Reavey, Bill Whitten, and Bob Mackie.

"Clothes designers, I think when you wear their clothes, they become part of you and they become your friends. . . . And that's why I like to have relationships with designers, because you get to know them, they get to know you, and you have fun with them. Every designer I've ever worked with, I've had so much fun with, and I've never asked them to make me something special. It's always what they want. You know, it's their idea."

Of course, not every outfit is one he'd want to repeat today as he's wrapping up his final tour, Farewell Yellow Brick Road, after sixty years in the business, excited to spend more time with his husband and two sons.

"I used to wear denim in the early '70s, and I absolutely loathe denim now. I think every piece of denim in the world should be burnt. I loathe it, I detest it, cancel it."

Although John may be saying a fond farewell to life on the road, he has recently released hit songs with both Dua Lipa and Britney Spears. We can only hope the "Your Song" and "Candle in the Wind" singer continues to grace us with his presence on red carpets and elsewhere for many years to come. For now, we can look forward to the release of his Disney+ documentary, *Goodbye Yellow Brick Road*, coinciding with his final US concert at Dodger Stadium.

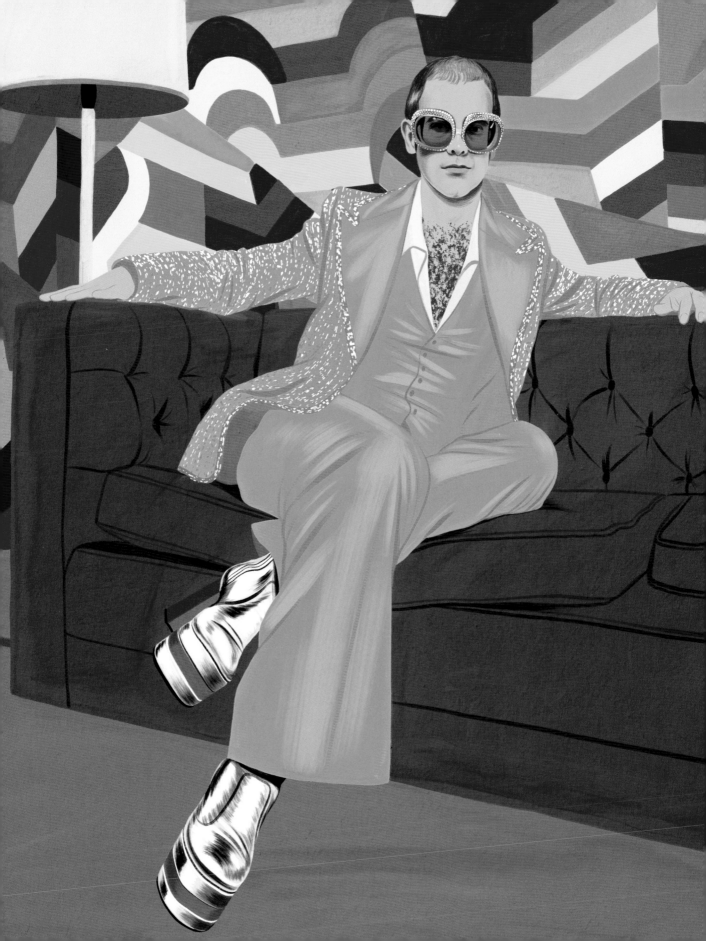

Grace Jones

"The first magazine to hire me was GQ in New York, but they wanted me to wear a wig. I remember flicking through it and thinking: 'I don't even recognize myself. This isn't going to work.'"

Grace Jones has evoked power for more than five decades as an essential presence in the fashion industry. Celebrating her seventy-fifth birthday, Jones is timeless and truly one of a kind, "a beauty icon for the ages."

She was born in Jamaica but raised in New York, where she eventually signed with Wilhelmina Models and shaved off all her hair in the late sixties. "It made me look more abstract, less tied to a specific race or sex or tribe. I was Black, but not Black; woman, but not woman; American, but Jamaican; African, but science fiction."

Moving to Paris in 1970, she found fame and success modeling for Yves Saint Laurent and Kenzo, photographed by the likes of Helmut Newton and Guy Bourdin.

With her hair styled in a flattop fade and her muscles well-toned, she's often represented androgynous fashion, but the lines of feminine and masculine seem unimportant when considering her undeniable appeal. She has graced the covers of *Elle*, *Vogue*, *Essence*, and *Ebony*, the photos often zoomed in on those angular cheekbones and captivating eyes.

Jones is a singer and actor, in addition to her modeling career. She released her debut album *Portfolio* in 1977 and became an essential part of the Studio 54 disco scene. In 1984, Jones played Zula in *Conan the Destroyer*, and she joined the Bond franchise in *A View to a Kill* in 1985.

She wrote *I'll Never Write My Memoirs*, and recently, she collaborated with fragrance brand Boy Smells on a candle inspired by the Caribbean. "After it rains in Jamaica, there's a smell that is just so, ah! It just brings everything back from my childhood."

Jones says "society dwells too much" on age, and if asked, "I just say I'm 5,000 years old." These days she can still pose in body paint or stun in haute couture. "How would I like to be remembered? Remember me as the whole tequila, worm and everything."

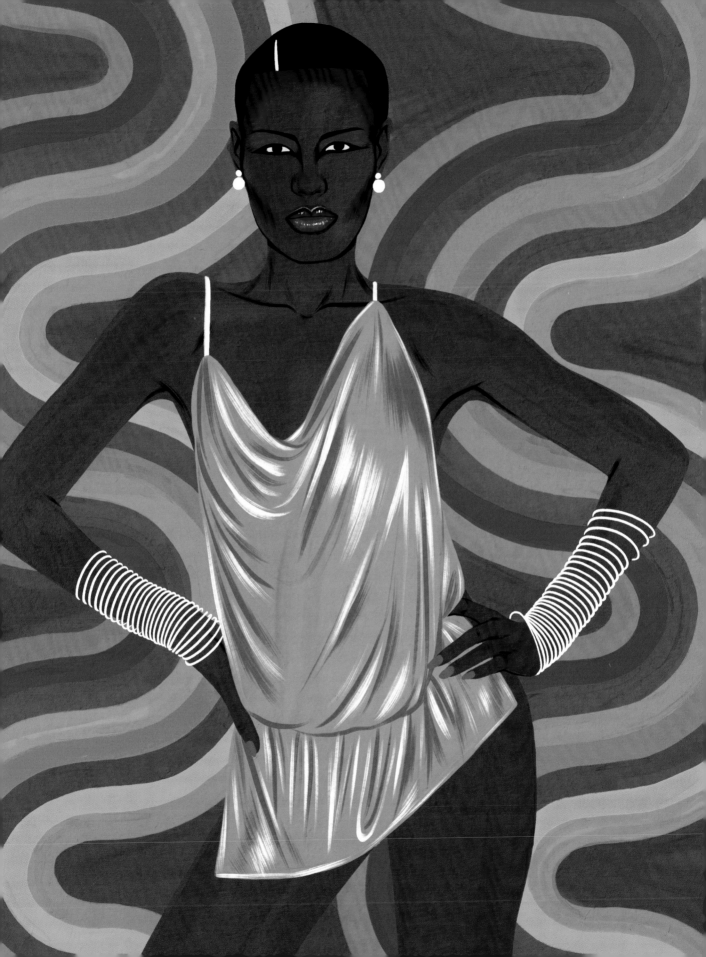

Frida Kahlo

"Fall in love with yourself, of life, and then of whoever you want."

Frida Kahlo's story is one of triumphing over hardship. Taking life's lemons and making exquisite lemonade—the likes of which have never truly been replicated.

"At the end of the day, we can endure much more than we think we can."

Born in 1907, Kahlo is known as one of the most important artists of the twentieth century. She painted lush depictions of Mexico, vibrant colors of wildlife, and many self-portraits—some alluding to the pain and injuries she suffered from childhood polio and a debilitating bus accident at age eighteen.

"I'd like to be able to be what I want to be—behind the curtain of madness: arranging flowers all day long; painting pain, love, and tenderness. I'd laugh as I pleased at the stupidity of others and everyone would say: poor thing, she's out of her mind."

Kahlo's striking appearance, including the long, romantic skirts and loose blouses she wore to hide her differences, gave her plenty of material to work from. During Frida's time, it was much more fashionable to appear French, but Kahlo's style was far from the norm of the era. It is widely considered true that her husband, artist Diego Rivera, preferred his wife dress in the Tehuana style, and she loved him madly.

Kahlo took cues from her mother as well. "[My mother] was a short woman with beautiful eyes, a very fine mouth, and dark skin—she was like a Oaxaca bellflower. When she went to market, she would fasten her belt gracefully and coquettishly carry her basket."

Kahlo's unique look included an untamed mustache and monobrow, which her husband called birds' wings; she had center-parted hair that was often elegantly coiffed and decorated with silk and metallic floral nosegays.

Within her self-portraits, the eyes were often staring directly at the viewer, as if daring them to question her.

"The most important part of the body is the brain. Of my face, I like the eyebrows and eyes."

Kahlo used cosmetics from Helena Rubinstein and Revlon nail varnishes, often sporting a necklace of pre-Columbian jade. She had a gift for finding beauty no matter life's circumstances. After one leg was amputated, she decorated her prosthetic leg with a bright-red boot with green, Chinese silk embroidery in pink and white.

After Kahlo's death in 1954, Rivera locked his wife's objects in her home's bathroom, and they were only brought out in 2004. This treasure trove included three hundred items of clothing, jewelry, and accessories, mostly cottons and silks well-preserved despite Mexico City's climate.

This collection has been celebrated—in the 2012 exhibition *Appearances Can Be Deceiving: The Dresses of Frida Kahlo* at the Museo Frida Kahlo in Mexico City and the 2018 exhibition *Frida Kahlo: Making Her Self Up* at the Victoria & Albert Museum in London.

Although underappreciated during her lifetime, Kahlo's influence today—often known as Fridamania—is clearly undeniable, whether in beauty, art, fashion, or as that of a strong, powerful woman.

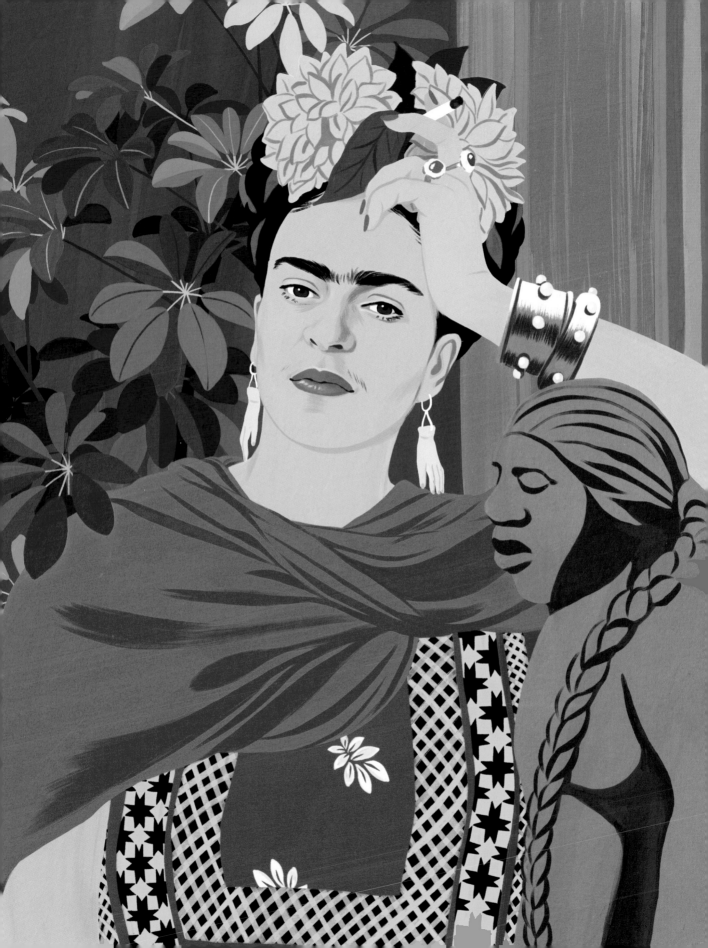

Rei Kawakubo

*"You think I'm not normal because you're looking at the clothes.
But I am. Can't rational people create mad work?"*

With her signature dark sunglasses and geometric bob haircut, Rei Kawakubo has been at the forefront of avant-garde fashion for more than fifty years.

Born in Tokyo in 1942, Rei Kawakubo grew to study fine arts and literature, earning a degree in "the history of aesthetics" at Keio University, where her father was an administrator. She worked in advertising for a textile manufacturer, and as she transitioned to becoming a stylist, she began to design clothes for her clients.

Kawakubo founded Comme des Garçons, and by 1980 the company had one hundred fifty franchised stores within Japan. She says her early designs featured a "denim apron skirt. Very popular. I made different versions of it."

She was nearly forty when she displayed her first collection in Paris, although she'd already made a name for herself in Japan. The reactions to her 1981 "Destroy" collection—with its abundance of black and asymmetrical cuts—were somewhat unfavorable, at least by the critics. Her vision of deconstructionism was divisive at the time, but in hindsight very influential. Still, the hoi polloi found plenty to admire about her style, whether it be the lack of sizes or the fact that its sole purpose wasn't to sell a woman's body to a mate.

"I never intended to start a revolution," Kawakubo said.

"I only came to Paris with the intention of showing what I thought was strong and beautiful. It just so happened that my notion was different from everybody else's."

When she began making clothes in the seventies, Kawakubo said it was for a woman "who is not swayed by what her husband thinks." She has called her style "rebellious" and "aggressive," but it is also not without femininity.

Comme des Garçons has collaborated with the likes of Nike, Vivienne Westwood, and H&M in Tokyo. "I have always been interested in the balance between creation and business." Kawakubo also established Dover Street Market, a department store with locations on three continents.

In 2017, the Metropolitan Museum of Art hosted an exhibition of her designs, with Rihanna wearing a sculptural Kawakubo design to the Met Gala to celebrate the show.

At eighty, Kawakubo is still putting in the work of creating collections that she calls "an exercise in suffering."

"The people of this era want to dress naturally, comfortably, stylishly and not much more. My business suffers if people shy away from clothes that are difficult to wear. When we really put our thoughts into a piece, it will become difficult to wear in some aspects. We need people to be OK with that and wish to wear it despite that."

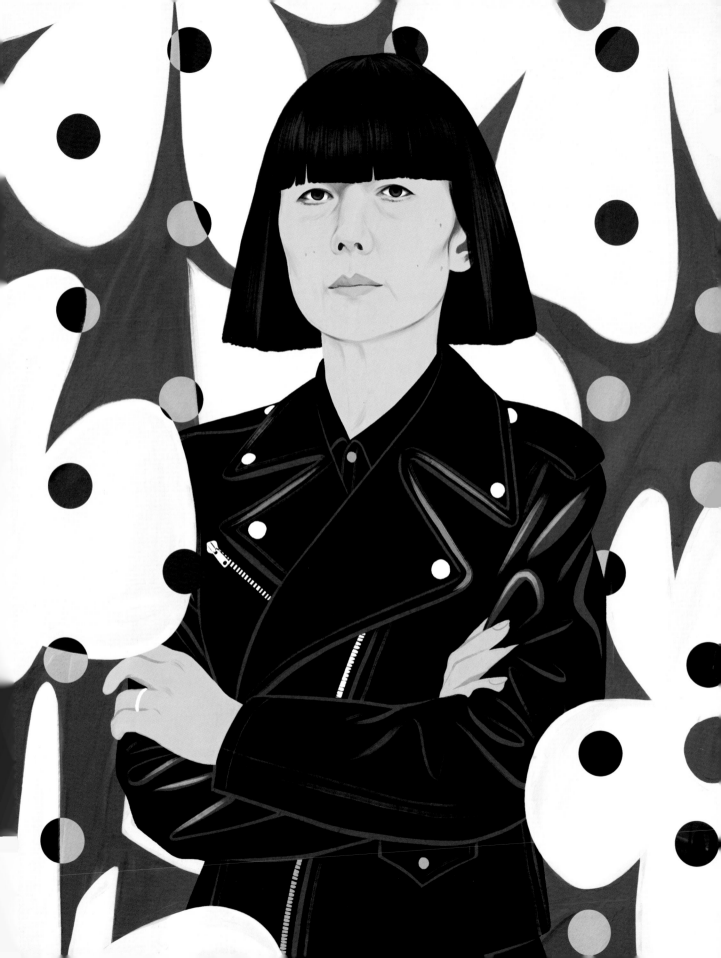

Diane Keaton

"I've had a lot of independence, and nobody's telling me what to do. I had a mother who encouraged that and helped me achieve the things I wanted to achieve. I've followed the paths I've wanted to follow. I like redoing houses, I like architecture, I like visuals, I like fashion, I like all of it."

Beginning her career in the 1970s, Diane Keaton has spent five decades in the spotlight. Born near Pasadena, California, Keaton moved to New York in the late sixties to study acting, becoming an understudy in the original production of *Hair* on Broadway. Then, Woody Allen began casting her in his projects.

Since then, she's appeared in more than fifty series and films, becoming such a fixture in the industry that it's difficult to imagine a time without her quirky personality, self-deprecating humor, and, of course, her truly unique fashion sense that has contributed so inherently to many memorable performances.

"Even when I was young, I was way into fashion. My mom and I used to pick out patterns, and then I'd tell her what I wanted, and she'd do it for me."

Tailoring, voluminous skirts, extra-wide belts, high-wasted pants, plenty of scarves, a neutral palette of black, white, beige, and gray, and don't forget her dramatic hat game.

"I've admired [the menswear] look early on from the streets of New York in the 1970s. Women wearing pants and ties. A lot of people were doing that. It was Ralph Lauren in the early days. He was one of the first to do a pant suit for women and give her a tie. It's not a new look. Katharine Hepburn and Marlene Dietrich both wore their suits and tuxes."

Keaton's *Annie Hall* ensemble (Ralph Lauren suit vest and tie) laid the foundation for her future style. "That was the beginning of me just playing around with whatever."

Keaton describes her personal style as "eclectic and original. How's that for you?" And she certainly doesn't consider herself any kind of fashion role model.

"I'm not [an icon]. . . . More like an idiot, I'll tell you that."

She's a fan of Thom Browne, Comme des Garçons, Dover Street Market, Egg in London, Noodle Stories in LA, as well as hats by Nick Fouquet and Baron Hats.

"I don't count my hats, but I've kept all my old hats. For me, a hat is a friend."

Keaton prefers to choose her own costumes when possible. "It's very protective [to style myself]. It hides a multitude of sins. Flaws, anxiety—things like that. I would not feel comfortable in a short skirt or something cut off with my arms hanging out there. And I've always liked hats. They just frame a head. But, of course, nobody really thinks they're as great as I do."

She's won an Academy Award, written books, made wine, flipped houses, and raised two children. And whatever comes next, she's here for it.

"I want to be engaged in life. Even though it's kind of an odd one, I'm really happy."

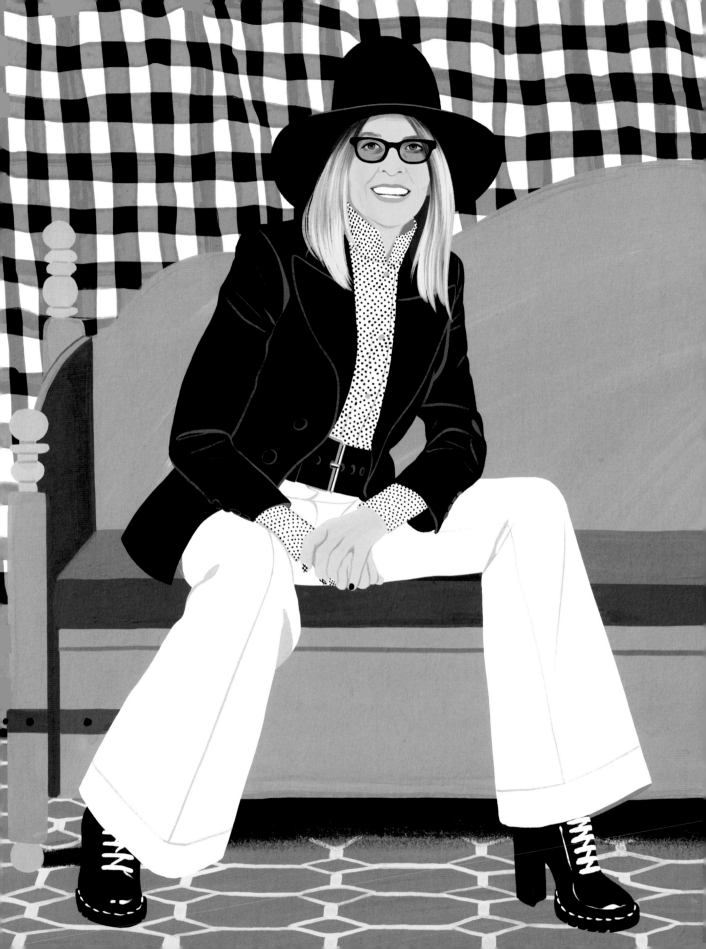

Solange Knowles

"I'm a lot more interested in style than fashion—style is what makes us who we are."

Fighting the constant label of Beyoncé's little sister—she spent years as a backup dancer and singer for Destiny's Child—Solange Knowles released her debut album, *Solo Star*, at age sixteen.

"I have been writing songs since I was nine years old, so writing has and always will be my first love and passion."

Knowles tried her hand at acting and continued songwriting for herself and other artists, eventually releasing two additional albums and founding her own Sony imprint, Saint Records. In 2016, she stunned and impressed when she presented her 2016 album, *A Seat at The Table*, as a work of performance art.

"I'm not at all interested in entertainment. I'm really interested in energy exchange between the viewer and the performer. One way to do that is to make an inclusive experience through style, through energy, through space."

In 2017, Knowles was honored with the Billboard Impact Award for Women in Music in response to *A Seat at The Table*.

Fashion and costume are an integral part of her identity and art, whether it be the bold looks she's worn on the red carpet or the more minimalist aesthetic she utilizes in her performance art, despite pushback. "I will never forget the range of emotions I felt. This idea that Black women could not be minimalist, we could not be subtle—we have to be big, we have to be loud, we have to be an explosive presence."

Knowles has worn seemingly every designer, including Alessandra Rich, Rachel Roy, Marni, Kenzo, Salvatore Ferragamo, Louis Vuitton, and Gucci. Her looks have ranged from textured knits and structural statements to signature gowns (see: bright yellow Jean Paul Gaultier) and shimmering suits; she doesn't shy away from color, although she frequently stuns in angelic white.

In 2020, she styled herself for her own *Harper's Bazaar* digital cover and photo shoot, accompanied by a series of her poems and essays. She wrote in one selection: "My body is not just a vessel, it is truth. It is living, breathing, alive and well. What will you do with her? I've been hanging my clothes on clotheslines, wondering if they will tell me their secrets. If I can air out their demons. If the water from the ends of hemlines can give breath to the grass it arrives on. Making a ritual of hand washing my silks in cold water."

A Grammy-winning singer-songwriter, a composer, an actress, and a constant presence in the fashion world, Knowles has partnered with Puma and Calvin Klein, appeared as the face of Rimmel London makeup, and modeled for Dereon.

She released *When I Get Home* in 2019, and in 2022, Knowles released art book *In Past Pupils and Smiles*, which chronicles her 2019 performance art piece of the same name.

"I remember being really young and having this voice inside that told me to trust my gut. And my gut has been really, really strong in my life. It's pretty vocal and it leads me. Sometimes I haven't listened, and those times didn't end up very well for me."

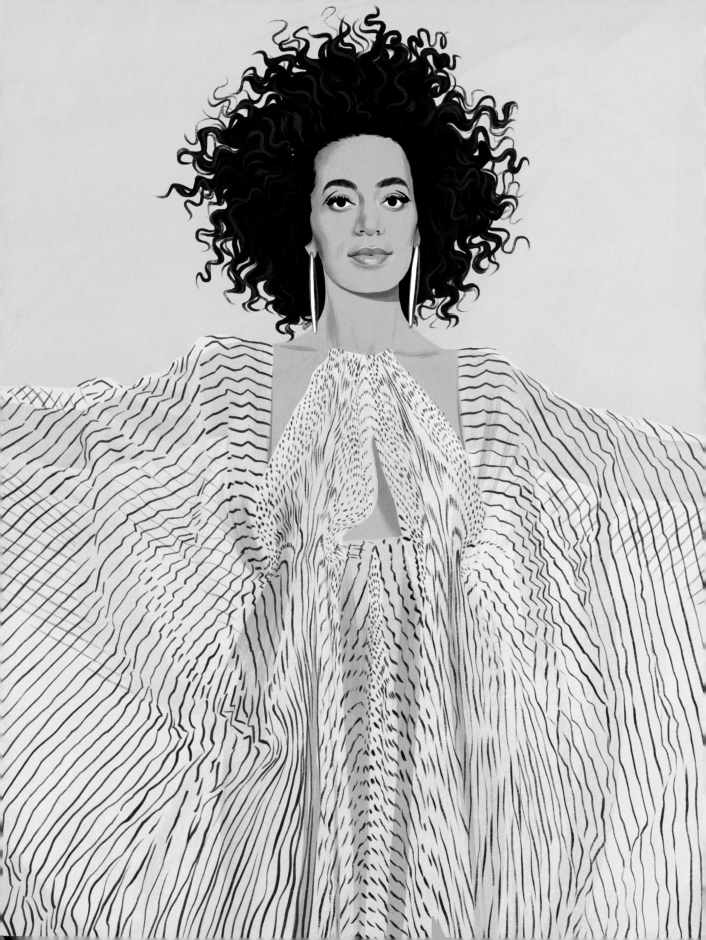

Shirley Kurata

"We are all human, and we have our insecurities, and that's OK. What makes us cool, ultimately, are the sincere and interesting and unique things that we create and do and believe in. Some of the coolest people I know are self-possessed geeks. So embrace your inner nerd! And your inner uniqueness!"

A Los Angeles-based stylist and creative collaborator who never shies away from color, Shirley Kurata embraces bold patterns and vivid vintage, describing her own personal style as "mod secretary."

She's known for styling campaigns including Target, Volkswagen, Clinique, and Westfield, becoming a staple in the fashion industry in the '90s. Kurata has collaborated on runway campaigns (Rodarte), fashion spreads (*Vogue Taiwan*), advertising (The Venetian), music videos (Selena Gomez), television series (*Genera+ion*), and major motion pictures (*Alpha Dog*).

Recently she took on *Everything Everywhere All At Once* as costume designer and wardrobe stylist with a limited budget. "It feels so great to work on a project where I was given such free rein to be creative. It is also so exciting to hear such great feedback from people who have watched the film. . . . I'm also proud to be part of a movie that gives a voice to the Asian American narrative in a way that is totally unique, thoughtful, and creative but resonates universally in its message of love, acceptance, and empathy."

It's an important message for Kurata who has said she didn't fit in at her "predominantly white and preppy school. . . . One of the seniors asked me earnestly, 'Do you speak English?'"

"I was really into Japanese magazines. I loved the fashion and styling and would try to do my own version." She studied art at Cal State University Long Beach and moved to Paris to study fashion design.

Kurata has styled Pharrell for his role on *The Voice*, as well as Billie Eilish, Mindy Kaling, Aziz Ansari, and Lena Dunham, and she's been featured in *Paper* and *Nuvo*. In 2015, with husband Charlie Staunton, she opened the Virgil Normal boutique, which carries new and vintage menswear.

"Having the shop has been really fulfilling and it was kind of a surprise to me because it's beyond just having a store, it's having a community. Having events here, being part of this neighborhood, we've met so many people, artists, designers."

But she's not finished conquering the industry just yet. "For me, it was a long path. It wasn't like I was discovered, I didn't have the contacts. I worked on the crappiest low-budget movies for years. It was very slow and it took a lot of hard work to get to where I am now. I'm still not even where I could be, but getting there."

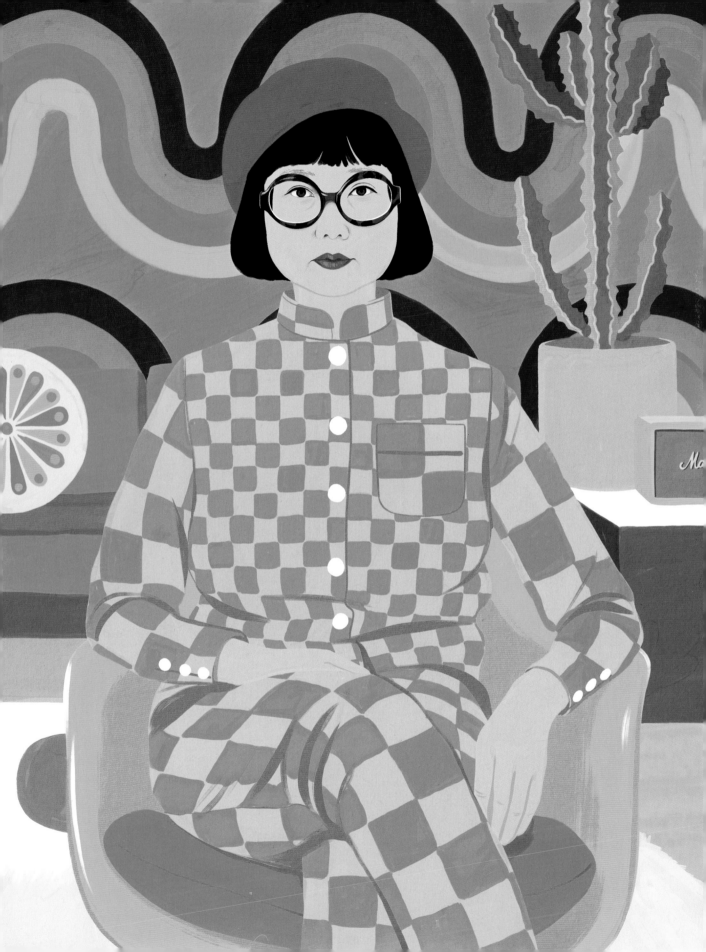

Yayoi Kusama

"I get mountainous energy from creating works with polka dots and infinity nets motifs. So much that I never get tired."

How many ninety-three-year-olds come to mind when you think of style icons? Perhaps not a one, but Yayoi Kusama undoubtedly deserves a spot among the echelon of fashionistas giving us bold and beautiful all her life long.

Born and raised in Japan, she moved to New York City in 1958, making her mark on the New York art scene throughout the sixties. In addition to her paintings, installations, and performance art, fashion has been a significant aspect of Kusama's oeuvre since the beginning.

In 1968, she founded the Kusama Fashion Company Ltd. and began selling her avant-garde, hole-filled creations at Bloomingdale's and elsewhere. Around that time, she also created a one-of-a-kind wedding gown—for two men. "I presided over what must have been the first wedding party between two gay men in America," she said in an interview with *Index* magazine. "I made a dress for two, that is, a dress that two people could wear together."

If you know of Kusama, then you probably know of her penchant for polka dots—an oft-used element in her six-plus decades' worth of internationally acclaimed pop art. But polka dots aren't strictly a part of her multimedia art, rather she's famous for displaying them confidently on her person as well—along with her signature bright red, chin-length wig—using fashion as an extension of her installations to personally camouflage into the same patterns.

Over the years, her passion for the polka dot certainly hasn't waned. In her autobiography, *Infinity Net*, she explores the concept of "one polka dot: a single particle among billions." "My passion [for polka dots] has never changed. I am desperate to create more and more works."

Her 2012 collaboration with Louis Vuitton, under the helm of creative director Marc Jacobs, included a collection of polka-dotted bags, accessories, and ready-to-wear items. Ten years later, Kusama teamed up with Louis Vuitton for another collection inspired by her "Infinity Mirrored Room," and her popularity continues to grow thanks to the prevalence of social media, with tickets for her exhibitions selling out before opening day.

Success never came easy to Kusama—her acclaim has been hard-won—but through it all her message of unity has been consistent. This applies to her thoughts on fashion as well. In her autobiography, Kusama shared this sentiment: "Clothes should bring people together, not separate them."

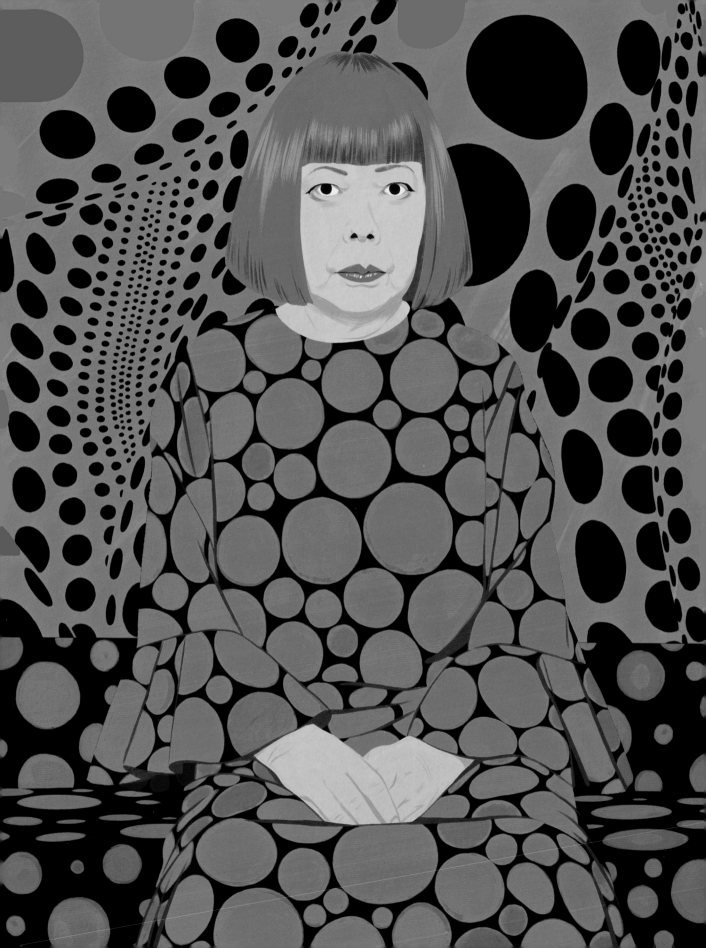

Spike Lee

"Let's make sure that Virgil Abloh suit is noted as fuchsia for the record. It's not pink, it's fuchsia, and there is a story behind it. That was my late mother Jacqueline Carroll Shelton Lee's favorite color. It was a tribute to my mother."

He's an avid sports fan, a tried-and-true New Yorker, and, of course, a celebrated filmmaker, finally earning his first Oscar in 2019 for *BlacKkKlansman*. And whether he's courtside at a Knicks game, teaching at NYU, or attending a film premiere, Spike Lee has a swagger all his own that he's been showing off since his first film, *She's Gotta Have It*, in 1986.

"I don't think about what I wear usually. I just wear what I'm comfortable with wearing and that's it. I literally just throw some clothes on and get on with my day."

Then again, it was a consideration for his apparel in 1996 that led to a relationship with sporting brand New Era, for which he has now designed his own series of caps.

"I just wanted a red Yankees hat to go with my bomber jacket during the 1996 World Series, and the design team in New Orleans said we would have to ask the Yankees first. We did that and surprisingly the owner said OK. Whoever allowed me to have that red New York Yankees cap for the World Series made a good decision that day."

Lee attended Morehouse College, decided to be a filmmaker in the summer of 1977, and after graduating in 1979, he gained entrance to NYU grad film school. His thesis film won a Student Academy Award and put him on the path to the success he's earned since.

And even from his first film, he's incorporated a fondness for fashion into his work.

"The first film, *She's Gotta Have It*, it's not a mistake that Mars Blackmon was wearing Jordans. That wasn't a mistake. It wasn't a mistake that Mars Blackmon was wearing Cazals. It wasn't a mistake that Mars Blackmon was wearing that Brooklyn bicycle hat. . . . You know, I know what's happenin'. I live here in New York. You just walk out the street and it's there."

He often sports signature round spectacles, a tasteful chapeau, and a snazzy suit, like the fuchsia, double-breasted design by Virgil Abloh for Louis Vuitton he wore to the 2021 Cannes Film Festival. Of course, it's easy to determine his favorite accessory: "Sneakers for sure! I absolutely love sneakers. Jordans or Nikes. They're my go-to brands."

At the 2019 Academy Awards, Lee donned a purple suit by Ozwald Boateng and sneakers designed by Tiner Hatfield.

"I told Ozwald to make my pants high-waters so they see the Jordans. I don't care what nobody's wearing. I win the Oscar on the red carpet. Men, women, I don't care if they're wearing fifteen-inch heels. They can't be messing with the Jordans I'm going to be wearing. I'm going to be as clean as the board of health. I'm going to be sharp as a razor."

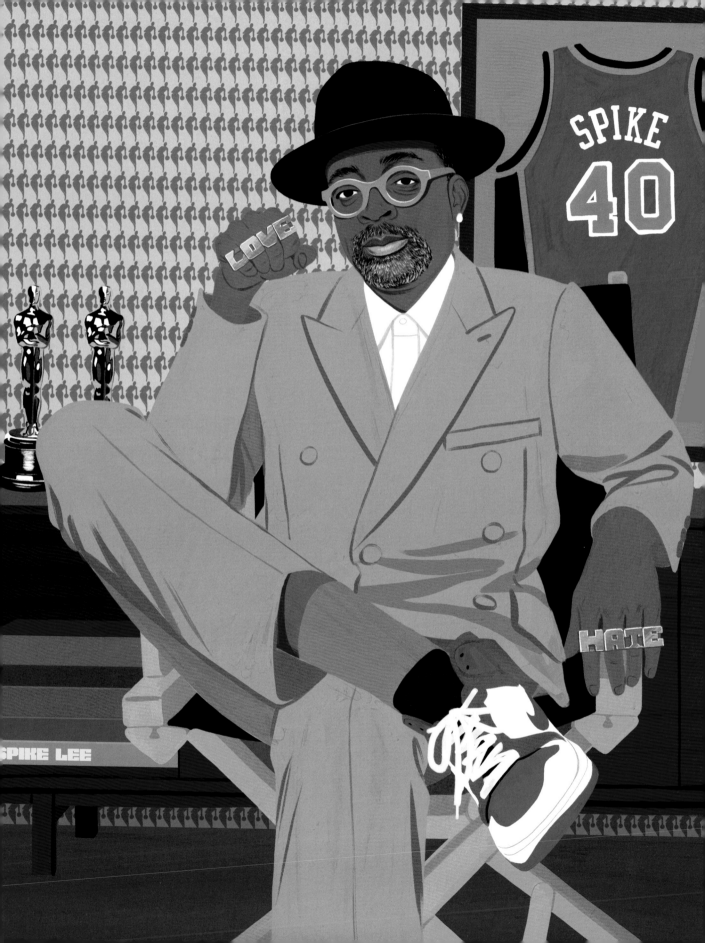

Antonio Lopez

"I always want to know what's new, that's why I love the street. I get so many ideas just walking around New York or Paris."

The sixties saw Puerto Rican-born Antonio Lopez break out on the fashion scene with his bold and dynamic fashion illustrations, which he created with art director Juan Ramos—a collaboration that would last for more than twenty years.

"When I arrived in the world of fashion, illustration was a dead art . . . I did a transfusion."

As a preteen, Lopez attended New York's Traphagen School of Fashion and then the High School of Art and Design before the Fashion Institute of Technology. There he met Ramos, a fellow Puerto Rican, and their creative partnership began. In 1962 he dropped out of FIT to work for *Women's Wear Daily* full-time, but they let Lopez go when he began freelancing for the *New York Times*.

Described as an arbiter of style, Lopez worked with many fashion designers and magazines, collaborating on his illustrations, doing design work, creating collections, and working as a stylist. His working relationship with artistic partner Ramos was symbiotic, their personal relationship sometimes romantic, more often not.

Along with his immeasurable tangible contributions, Lopez is credited with discovering models like Jerry Hall. Often championing women of color and unconventional beauties, "Antonio's girls," as they were known, included Grace Jones, Donna Jordan, Pat Cleveland, Carol LaBrie, Alva Chinn, and Amina Warsuma.

Lopez, a style maven in his own right, appeared on the cover of *Interview* magazine in August 1973, sporting his signature fedora. He bought his shirts from Mr. Fish of London, his boots were snakeskin, and his hats made of velvet.

His fashion illustration work—admired by Salvador Dali and Helmut Newton—includes the April 1975 *Interview* magazine cover with Brigitte Bardot and a drawing of James Dean for *GQ*. He used clear, pure lines and bright colors in his commissions for Bloomingdale's and various publications, and worked closely with Karl Lagerfeld. For a time he served as *Interview* magazine's in-house designer, collaborating closely with Andy Warhol as well.

Rather than create from a photograph, Lopez preferred a living, breathing subject. "I like to work with a model, I find the drawings more spirited, more believable."

Sadly, Lopez's life was cut short at just forty-four when he fell victim to AIDS in 1987. His partner, Ramos, met the same fate only eight years later.

Today, Lopez's legacy lives on in a monograph, *Antonio: Fashion, Art, Sex & Disco*, published in 2012; a comprehensive retrospective (more than 400 pieces) of his work, *Antonio Lopez: Future Funk Fashion*, at El Museo del Barrio in 2016; and a 2018 documentary titled *Antonio Lopez 1970: Sex, Fashion & Disco* directed by James Crump.

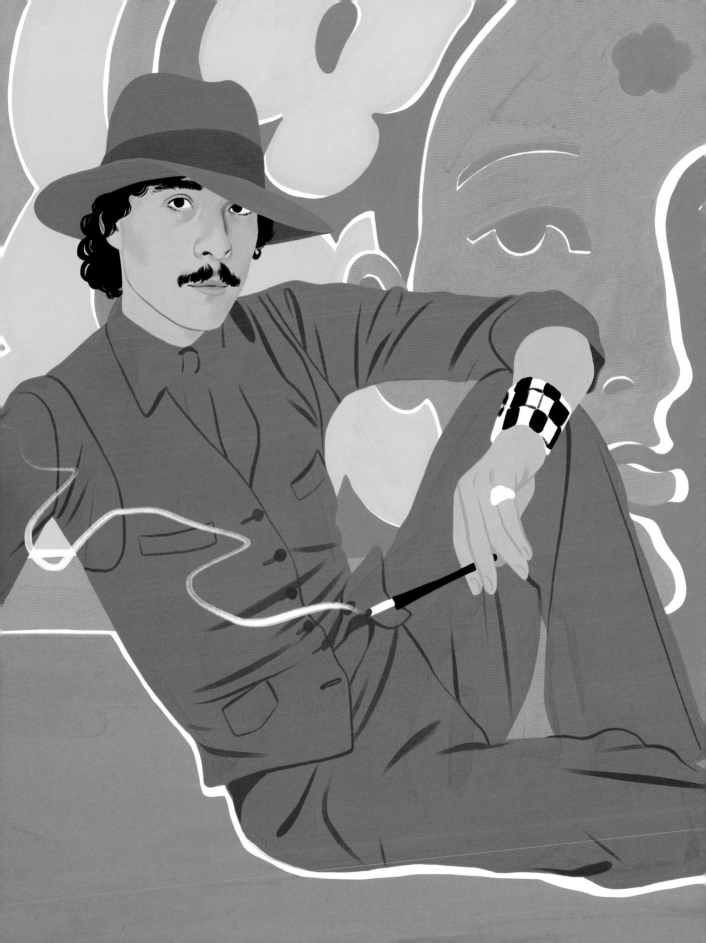

Madonna

"I am my own experiment. I am my own work of art."

An entire book could be written about Madonna's fashion (and a few have been)—from cone bras to crucifixes, haute couture to denim on denim.

As the story goes, it was 1979 when Madonna left Rochester Hills, Michigan, for New York with thirty-five dollars in her pocket.

"When I first came to New York and started making music, I didn't have a lot of money. I was one of a billion girls walking around New York City, looking for a job and wanting to be somebody. How do you stand out when you don't have a lot of money? Personal style!"

Her style has never been lacking, from her 1983 "Lucky Star" music video—in a black mesh crop top, fingerless lace gloves, black ribbon in her hair, with plenty of star and crucifix accessories—to her more recent ventures, with her own clothing, fragrance, and accessory lines. Her daughter, Lourdes, is her co-collaborator.

"I don't take the job of creating anything—whether it's fragrance, or beauty products, or clothes—lightly, and I need a lot of time to do stuff. I don't like it when other people create for me."

She's the best-selling female artist of all time, inducted into the UK Music Hall of Fame in 2004, an actress (she won a Golden Globe for *Evita*), producer, director, and so well-known that she requires only one name. A true original. And every time she reinvents herself, people take notice.

"I don't believe there's a certain age where you can't say and feel and be who you want to be."

In the eighties, there was the pink, plastic bustier, big hair, and plenty of jewelry. The white corset with tulle skirt and "Boy Toy" belt buckle. The black-and-gold embellished jacket and stacks of bracelets in *Desperately Seeking Susan*. In the nineties, the all-black suit, sheer lace top with black bra; the spiky pink corset and cone bra, designed by Jean Paul Gaultier. And every decade since, she's made her mark.

When the "Queen of Pop" performed at the Super Bowl in 2012, she wore a glittery Egyptian caftan, Philip Treacy headpieces, and priest robes. In 2017, she sported Gucci, Christian Dior, and Stella McCartney in *Harper's Bazaar*. And gracing the global stage of the Met Gala in 2018, she donned a voluminous black Jean Paul Gaultier gown. All along the way, for more than twenty years, she's been working with stylist and costume designer Arianne Phillips.

"I like to be provocative. I like to make people think. I like to touch people's hearts. And if I can do all three of those things in one fell swoop, then I feel like I've really accomplished something."

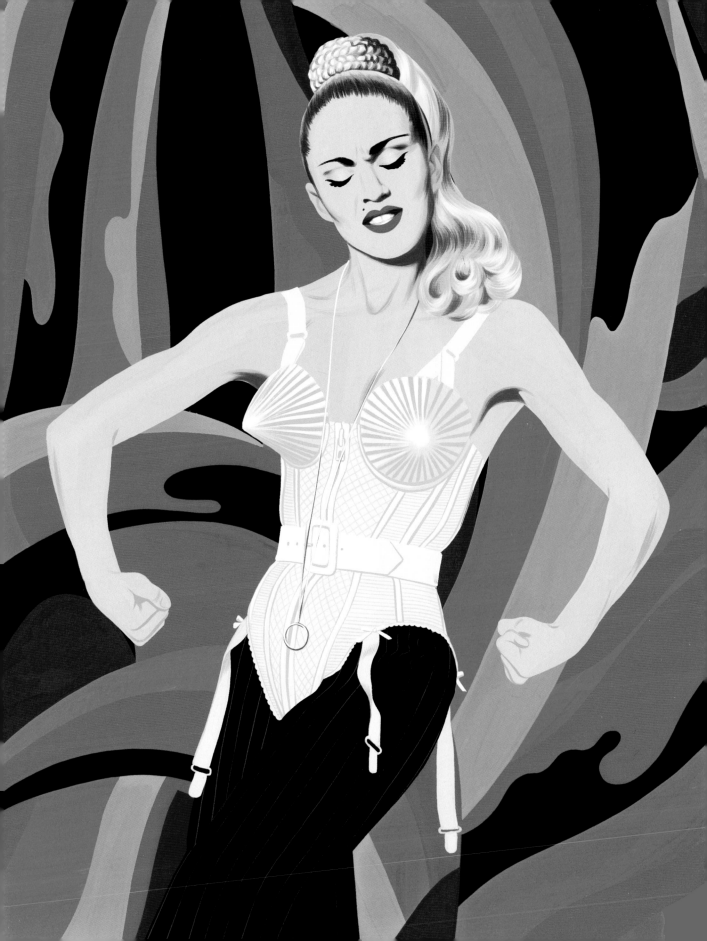

Kristen McMenamy

"I never had one style. It's always been a day to day, how I'm feeling, what's the weather like kind of situation."

It's a new era of fashion, and sometimes that means looking to the past. Iconic 1990s model Kristen McMenamy is experiencing a renaissance of sorts, appearing on the covers of *Vogue Italia* and *i-D* magazine, thanks in part to finally breaking down and joining Instagram.

Born into an Irish-American Catholic family in Buffalo, New York, McMenamy also spent time growing up in Pennsylvania, the third of seven children. "I hated my face. I still do. I know I photograph well, that I am a great model, but I've always looked at myself and thought: 'God, I am so ugly.'"

She developed a passion for modeling early on, eventually dropping out of college and traveling to Manhattan on go-sees.

"When I had no money, I did the thrift stores and I made up on my own stuff. I would see people laughing at me on the street and it hurt a little, as it was just me."

Receiving rejections from Eileen Ford and others was difficult, but in 1991, the Legends agency took a chance and sent McMenamy to Paris and Tokyo. Photographer Peter Lindbergh was one of the first to recognize her appeal, and Karl Lagerfeld cast her in a couture campaign in 1992.

"When I was modeling, Karl would give me something and then I would cut it up, and I would walk back into the showroom in what was meant to be a floor-length skirt, but which was now almost a pair of underwear. I'm sure he was horrified."

After cutting her long, pale-red hair short and dying it blonde (combined with François Nars shaving off her eyebrows), McMenamy became the poster girl for grunge. She was adored by photographers like Richard Avedon, Juergen Teller, and Steven Meisel.

Her recent return to the spotlight has been somewhat tentative.

"I don't take chances anymore, as how much time do I have left? But if there are great photographers, stylists, or filmmakers, it still gets me really excited." In the past several years, she's appeared on the cover of *W*, as well as in campaigns for Valentino, Marc Jacobs, and Balenciaga. McMenamy also shot the cover story for the January 2022 issue of *British Vogue* with Steven Meisel. "He makes a girl feel like a million dollars."

McMenamy first made her name as the face of Chanel and Versace in the late eighties and early nineties. These days, in addition to her modeling work, she's putting it all out there on Instagram (counting Naomi Campbell, Alessandro Michele, and Marc Jacobs among her followers). On the platform, she's appeared in a Molly Goddard ruffled gown over an acid green Balenciaga cycling top, yellow hoodie and sweatpants by Palace, and, of course, completely naked.

"My daughter got me into a few brands because she works with all the cool new designers, like Chopova Lowena. She was wearing one of their dresses, and I said, 'Where did you get that dress? It's just the most incredibly bonkers, beautiful dress!' Since then, I've been a fan. I adore Marine Serre. It's such a simple idea but it fits so correctly. I'm a Gucci girl too, and at Balenciaga, what Demna does is incredible."

At the end of the day, she's a performer who can appreciate a little fangirling when it comes. "I went out to my friend's book launch the other week, and I had three people come up saying, 'We love your Instagram, and you're our favorite model, can we have a picture?' My heart was bursting out of my chest, I was like, 'Oh my god!' Somebody said, 'Doesn't that bother you?' And I was like, *Bother me*? Are you out of your little mind? Of course not!' It's wonderful to be told you're great. Who doesn't love that?"

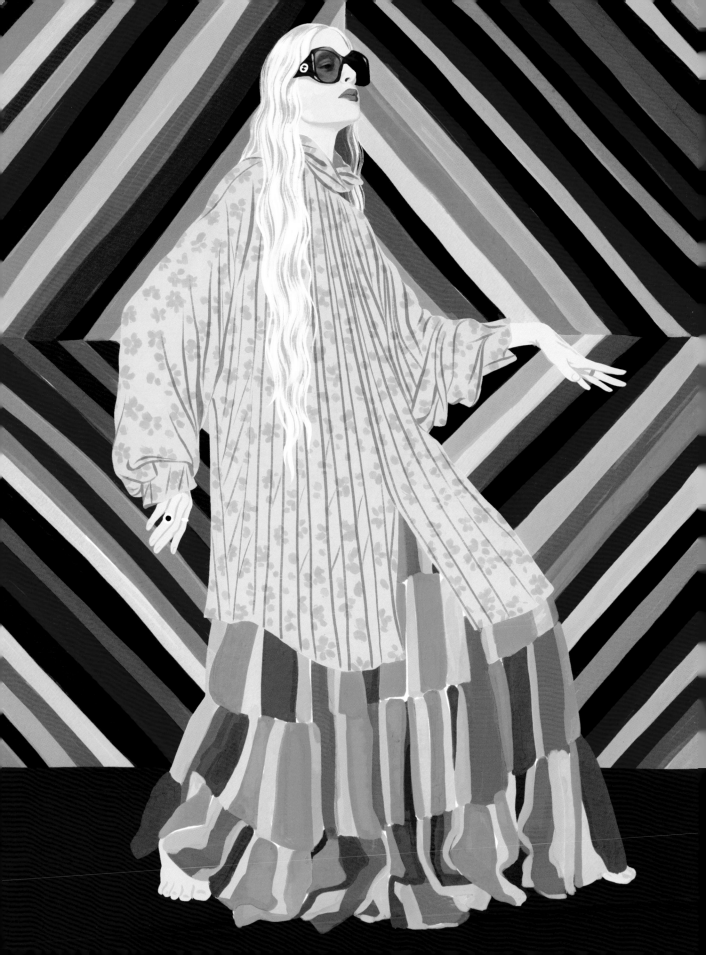

Alessandro Michele

"Sometimes people think that fashion is just a good dress, but it's not. It's a bigger reflection of history and social change and very powerful things. If you want to produce something new, especially now, you need more languages."

He may not have been the most obvious choice when he was appointed creative director of Gucci in 2015, but having worked for the company since 2002, Italian designer Alessandro Michele was highly respected and considered extremely talented.

"Being in charge of a brand like Gucci is really an unbelievable position in terms of responsibility—so many people and expectations are invested in it."

Prior to his appointment, he was made associate to then-director Frida Giannini in 2011 (lauded for his "provocative androgyny" working on the men's collection), and in 2014 became creative director of porcelain brand Richard Ginori. Before his time at Gucci, Michele worked as senior accessories designer for Fendi.

After three years as creative director, Michele spoke with Gucci chief Marco Bizzarri, and a no-fur policy was implemented. "I love craftsmanship. I'm crazy for the beautiful things you can do with your hands, so I try to put all these things into other materials—nothing is just lost."

Michele originally studied costume design, and his runway shows still feature theatrical elements. He is also known for gender-neutral styles and incorporating vintage elements.

"Fashion is like pop music in the eighties—something that is alive, not just in the boutique for rich people."

Michele's clientele is varied and plentiful, including celebrities who have walked in his runway shows, like Jared Leto, Phoebe Bridgers, Jodie Turner-Smith, and Macaulay Culkin. Many others have strutted confidently on the red carpet clothed in Michele's designs—Miles Teller, Tom Hiddleston, Beyoncé, and Margot Robie, to name a few, and the designer has a close friendship with fellow fashion icon himself, Elton John.

"I really love men's suits. They are perhaps one of the things I like most. I love the shoulders, the buttons. The jacket is an amazing item—one that cuts across sexes and identities." Michele's own ornate, personal style includes his iconic moment twinning in embroidered tweed tuxes with Jared Leto for the Met Gala, complete with matching sunglasses, gloves, rust red clutches, and clips for the side part in their identical long hairstyles.

The designer is constantly evolving, continually learning as he manned Gucci's helm. "After four years," he said in 2019, "I understood that I needed to be more concentrated on the creativity and the process: the stories that I'm telling, the experience of the clients in the store, the collection, the show—the music, the atmosphere."

To that end, the Gucci Spring/Summer 2023 Twins show will go down in fashion history. The hand-holding, identical twins on the runway created a sensation that will not soon be forgotten.

On the heels of this seminal show, Michele announced his decision to leave Gucci, wishing his former home nothing but the best: "Without them, none of what I built would have been possible. To them goes my sincerest wish: may you continue to cultivate your dreams, the subtle and intangible matter that makes life worth living."

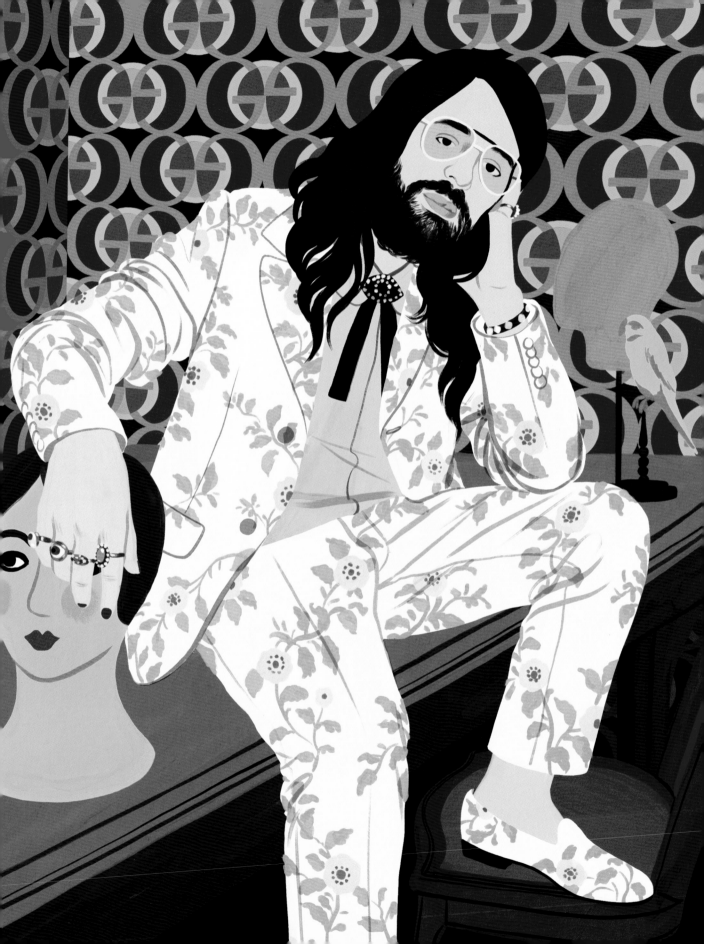

Peggy Moffitt

"I have devoted most of my professional life to Rudi Gernreich. I believed totally in his talent and had the great privilege of knowing him as a dear friend. Through the years we developed as a team. One of the great signs of his genius was that he allowed me to express my talent fully. We had indescribable fun together and shared the romance of creativity and collaboration."

Born and raised in Hollywood, Peggy Moffitt moved to New York at a young age to study dance and theater. "I always wanted to be a dancer. I have always been interested in movement more than the old-fashioned thing of having to fit yourself into somebody's preconceived form rather than have your body be the form."

She studied ballet under Martha Graham but found her teaching skills lacking. "She just came and was Martha Graham all over the place without teaching." Her experience with acting teacher Sydney Pollack was quite the opposite. "He was terribly, terribly gifted. Sydney Pollack was a genius and he was brilliant."

Moffitt returned to Los Angeles and appeared in films like *You're Never Too Young* and *Meet Me in Las Vegas*. But when advised to try modeling instead, Moffitt found work in Paris and signed with American designer Gus Tassell. This led Moffitt to meet Tassell's friend Rudi Gernreich, an introduction that would shape and guide her career for years to come. Moffitt became Gernreich's undisputed muse, wearing his bold and graphic designs and sporting her iconic Vidal Sassoon asymmetrical, jet-black bob and Kabuki-like eye makeup.

When her renowned husband, William Claxton, took photographs of Moffitt in Gernreich's topless monokini (published in *Women's Wear Daily*), the response was enormous. The monokini was a symbol of women's freedom and liberation, and the black-and-white photo solidified Moffitt's stardom.

"I don't think I modeled like other people. I knew how to move in a different way. I used to change the way I walked by what I wore. If it was a little girl dress, I might walk pigeon-toed or I would often spoof it. If it was a men's gangster suit, I might do it in a very girly way. I liked to have fun with clothes."

Moffitt favored photography over showroom work. "I could make different shapes, which you can't do when you're walking. I could get in positions that were static positions. That was like dance in photography."

Moffitt's collaboration with Gernreich lasted many years and resulted in Moffitt owning the trademark to Gernreich's name after his death and penning a biography on the designer. But she also worked with European designers like Mary Quant and modeled for *British Vogue*.

In 2016, Moffitt developed her own line of activewear from her perch in the Hollywood Hills.

"I think fashion is dead," she said in 2016. ". . . Fashion fell off a long time ago. I can't tell you to the minute that it died. Probably when everybody started wearing pants."

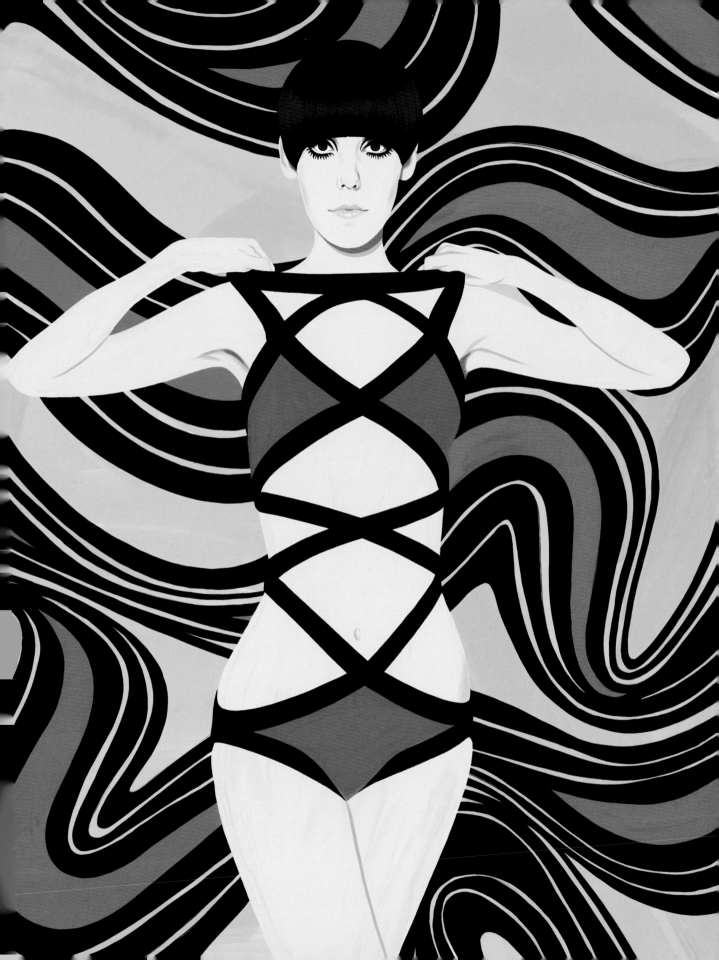

RuPaul

"It's no wonder that I'm involved in drag, because drag is about mocking identity, mocking the façade. Drag is an extension of the realization that, 'You mean, the thing I think I am, I'm not really?' Exactly. So have fun with it. Change it. That's why I think drag comes up against so much opposition from people, because the ego knows drag is a threat to the ego."

Easily the most famous drag queen to have ever held the title, RuPaul Andre Charles has been strutting his six-foot-four-inch stuff for decades now, inspiring generations of individuals to embrace their true selves.

Born in San Diego, RuPaul moved to Atlanta as a teenager to attend an arts high school and in 1982 landed a spot on *The American Music Show* with RuPaul and the U-Hauls. He continued to perform around the city, dancing and singing, promoting himself with posters and in clubs.

"I'm an opportunist and a show-off, so I knew show business would be my path. I didn't know how it would work, but I kept an open mind. Then I was in bands in Atlanta, and drag sort of happened to us. It was very different from the kind I do now—it was punk rock, with combat boots and smeared lipstick. But I knew I had power in drag because of the reaction I got from people."

RuPaul has released more than a dozen albums, written multiple books, and appeared in various films, including Spike Lee's *Crooklyn*. He was the face of M.A.C. Cosmetics, and in 2005 Jason Wu created a RuPaul doll.

Today RuPaul is the creator and star of the Emmy-winning *RuPaul's Drag Race*, an immensely popular reality competition franchise.

"The ideas for *Drag Race* came from my experience in the business. All the challenges came from everything I've done, which is radio, producing myself, marketing myself, dissecting what it is that could take me from below 14th Street to mainstream Betty and Joe Beercan. And we also wanted to celebrate drag as an art form, which during the post-9/11 era had really gone back underground."

In terms of his own style, RuPaul relies on designer Zaldy. The two met in the late eighties and began collaborating for the music video of RuPaul's 1992 single, "Supermodel."

"I wouldn't go anywhere without Zaldy. . . . Since ["Supermodel,"] our communication has gone from shorthand to telepathic. Bottom line, Zaldy gets it."

Surprisingly, RuPaul says he's never gotten used to himself in drag. "Even the first time, what struck me was how other people reacted to me, in a way that I'd never been reacted to before. So I thought, 'That's interesting. I'm gonna keep that information tucked away, maybe I can use that later.' And here we are."

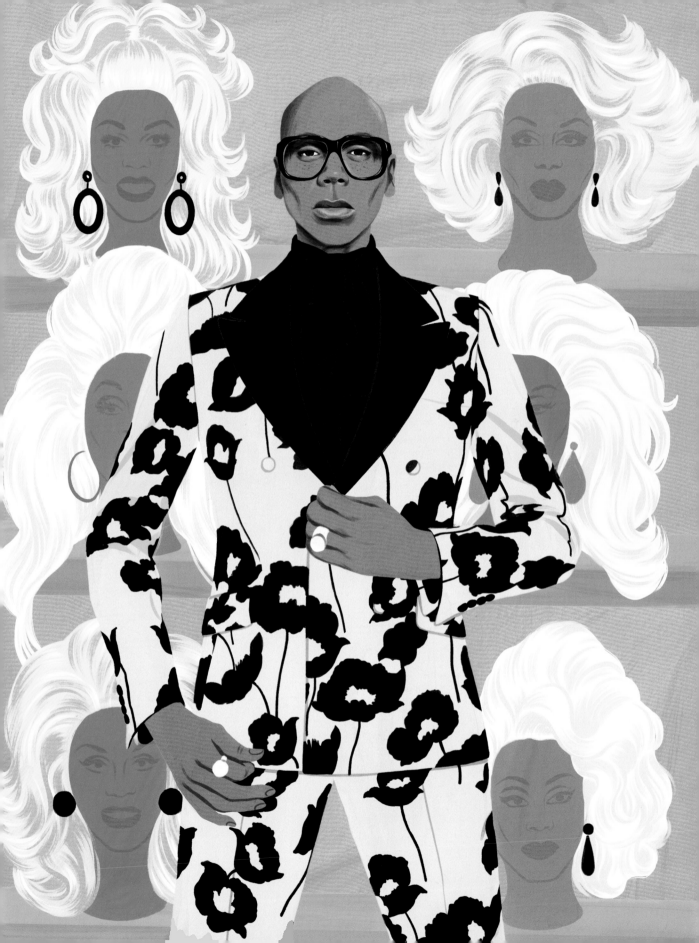

Rihanna

"When I found out I was pregnant, I thought to myself, there's no way I'm going to go shopping in no maternity aisle. I'm sorry—it's too much fun to get dressed up. I'm not going to let that part disappear because my body is changing."

Rihanna has had big dreams since she was a little girl of seven or eight growing up Robyn Fenty in Barbados, listening to Bob Marley and manifesting her destiny as a singer.

Signed to Def Jam at the age of sixteen, she's wasted no time taking the music, film, fashion, and beauty industries by storm, earning her place as the youngest self-made billionaire in America at thirty-four.

Undoubtedly a global superstar in the world of music—with hits like Grammy-award-winning "Umbrella" and "The Monster"—it is her accomplishments as an entrepreneur and visionary that have brought her to a new realm of success.

In 2017, Rihanna became the first Black woman to found a clothing line with LVMH, Fenty, and in the same year, she launched cosmetics brand Fenty Beauty, with an aim to make "women everywhere (feel) included." She has also collaborated with Puma (a line that sold out in hours), Manolo Blahnik, and River Island, among others.

And when Rihanna was pregnant, she embraced an opportunity to redefine societal limitations of maternity fashion every time she stepped out in the public eye. Attending Gucci's fall runway show in 2022, Rihanna celebrated her pregnant belly with Gucci's low-rise, leather pants, a shimmering headpiece reminiscent of Cleopatra, and of course, a black latex and lace crop top with purple faux-fur jacket.

"I'm hoping that we were able to redefine what's considered 'decent' for pregnant women. My body is doing incredible things right now, and I'm not going to be ashamed of that."

Her personal style has been making its mark on red carpets as long as we've known her—her Met Gala (and after-party) looks in particular have been unanimously revered—wearing Gucci, Marc Jacobs, Tom Ford, John Galliano, and Maximilian Davis, to name a few.

And with great wealth comes great responsibility—a burden Rihanna has born admirably with major involvement in a wide range of charitable causes, including her own organizations, the Believe and Clara Lionel foundations.

All in all, it's no wonder the Council of Fashion Designers of America presented Rihanna the 2014 Fashion Icon Award—a title she creatively reinvents and represents year after year.

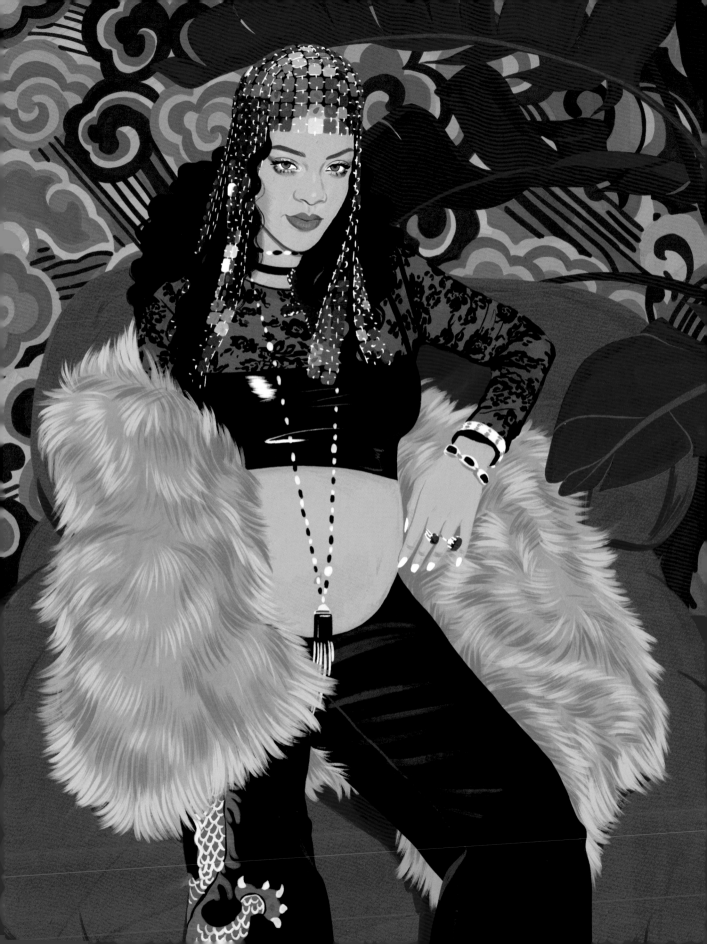

Simone Rocha

"My whole ethos is the idea of femininity and how that's integrated into women's lives, how it makes them feel. With every show you're telling a story, and you want to tell one that women connect with."

Rocha's aesthetic is beloved for its detailed, historically inspired interpretation of femininity. In portraits of the designer in her own designs, she conveys a timelessness and Old World quality that feels refreshingly new and original.

Growing up the daughter of Chinese designer father John Rocha, Simone Rocha thought it somewhat inevitable that she'd follow in his footsteps. "It was 100 percent a part of my life. But it's weird; it didn't feel very 'fashion.' Moving to London and being a fashion designer now, it's totally different."

She studied fashion at the National College of Art and Design in Dublin and Central Saint Martin's College in London, debuting her graduate collection at London Fashion Week in September 2010.

Rocha now owns stores in London, New York, and Hong Kong (with another location opening in Taipei soon), showcasing her signature furniture, hand-made sculptures, and of course, exclusive clothing and accessories.

Maya Rudolph, Natasha Lyonne, Keira Knightley, and Chloe Grace Moretz have all worn Rocha's designs, and Rihanna is a frequent fan, sporting Rocha's slippers, skirts, jackets, and shoes. Her clothes also entice artists like Cindy Sherman and Hope Atherton.

Rocha has earned impressive accolades in a short time, including the British Womenswear Designer Award in 2016 and the *Harper's Bazaar* Designer of the Year. Rocha has been constructing collections for more than ten years now, with plenty of fresh ideas with each show.

"With a catwalk show, I work on a collection for roughly six months, and it's very much that there's an inspiration and narrative that filters into these garments, and influences the fabrication, the silhouette, how you wear them, what they reveal, what they hide." Her aesthetic often features femininity, handcrafting, romance, and an individual palette. "[Red] symbolizes love, but also blood and pain. I love mixing it with other colors to see how that can create a new tension and friction."

She also draws on her Irish heritage for inspiration, and when she became a mother, incorporated swaddling clothes and nursing bras in her spring 2022 collection.

"[Having daughters] made me want to be very strong for them and really [show] them what you can do. I'm very proud of my work, and it's made me take it much more seriously. But at the same time, because one of my girls is six and she has this amazing innocence, the naïveté of that has also inspired me."

A$AP Rocky

"I've been experimenting in every field. I've been experimenting with style, with rhythm, with sonics, film, food, health, love, life—for real."

How many people can say they spent their jail time designing a collection on spec for Parisian designer Marine Serre? It's no secret that A$AP Rocky faced troubles in his younger life, but ever since he was a kid in Harlem, he's been able to turn to fashion as a positive outlet.

"I've been into fashion since birth. I grew up in the 'hood, and everybody in the 'hood wants to compensate for being in poverty, so they want to look good to keep themselves up. That's been embedded in me."

Rakim Myers grew up between Pennsylvania, the Bronx, and Harlem, sometimes living with his mother in shelters, dealing to pay the bills, and rapping as part of a large crew who all go by A$AP (Always Strive and Prosper). But at twenty-three he signed a $3 million record deal with Polo Grounds Music, releasing his first album *Long. Live. ASAP* in 2013, which debuted at number one on the Billboard 200 albums chart.

When he's not making music, A$AP Rocky is heavily invested in the fashion industry. And now he's wearing some of the very pieces he dreamed up in jail.

"I was definitely on that cot just thinking, *How will this ever come to fruition? How will I execute this? I hope I can execute this.* And God is good, bro. God is good. For real."

In addition to the collaboration with Marine Serre, A$AP Rocky has worked with Jonathan Anderson, Guess, and Needles, as well as designing his own Adidas and Vans sneakers.

"I really wanted to put myself in a position where I made a collaborative brand as opposed to being a brand that puts out shit just for the sake of accumulating capital. I'm all about making money! But I want to do it in the right way, fly way."

Since early only, he's been associated with designers like Rick Owens, Raf Simons, Prada, and Ann Demeulemeester.

"Things that I could never afford, people see me in more often now, 'cause I got the financials to go purchase them. [My style] definitely matured. There's a lot of things that I used to wear that I don't wear anymore, and there's a lot of things that I wore before that I'm in love with now, or things that I wore a long time ago that I brought back out."

Appearing in Gucci ads, designing a stiletto with Amina Muaddi, and serving as guest artistic director for PacSun, he's come a long way since wearing Gucci on his fourth birthday.

"I remember being poor and thinking, 'Man, I wish I could afford those clothes that Pharrell is wearing, or Kanye's wearing.' I couldn't afford it, so I would get a girlfriend to do it, or I would hustle. All I cared about was my clothes. When I was still broke, I felt like I had *more* style."

More recently he's developed his fondness for vintage.

"Nostalgia has a lot to borrow from. There's prior trends, and you've gotta thrift older clothes, [and with that] there's exclusivity which got me into older clothes. It's like, if I find this piece nobody else is going to have it, that's what the thrill is."

But he also recognizes that it's a balancing act. "Somebody shopping vintage head-to-toe is like someone shopping modern head-to-toe, like a bunch of brands: it doesn't look right when it's overkill. A splash of vintage, a splash of archival, a splash of modern, a splash of streetwear doesn't hurt."

A$AP Rocky is known for driving trends—Balenciaga life jackets or Gucci headscarves for instance—and his tastes know no gender bounds.

"Women's fashion started fashion, then they made menswear. Because fashion is derived exclusively from women's fashion, it's only right that you take . . . Like, when it comes to style, innovation, design, it's usually women's fashion that's at the forefront of doing something new."

In a feature for *GQ*, he wore Valentino, Gucci, a kilt by Vivienne Westwood, vintage jeans by Levi's, a vintage cross necklace by Cartier, and pearls by Chanel.

"I went around the world and I see influences from Copenhagen, France, London, all inspired by stuff that New York does, and vice versa. I like the way fashion is going. It's just like music—it doesn't matter what region you're from, you can adapt to any region for music or fashion. It doesn't matter like it used to."

In addition to sewing, patching, and tie-dying his own clothing, A$AP Rocky also possesses a unique and special skill, able to remember what people wore on a night out a decade ago—if he approved of their style choices. "I never really met too many people who can do that. It's kind of odd."

At the end of the day, A$AP Rocky values exclusivity and the importance of one-of-a-kind craftsmanship.

"Fashion trends come and go, but pieces stay with you forever."

Diana Ross

"[Fashion] has been part of my soul since I was a little girl. Putting things together from magazines and from store shop windows when I was unable to afford pretty dresses. . . . Follow your dreams, follow your passion, and do what makes you happy. Believe in yourself."

"It takes a long time to get to be a diva. I mean, you gotta work at it." And work at it she has. At seventy-eight years old, Diana Ross has been the Queen of Motown for sixty fabulous years.

In 1950s Detroit, Ross enrolled in cosmetology school while attending high school, and she's been doing her own hair and makeup—and many others'—ever since. She became the lead singer of the Supremes (originally called the Primettes) in 1959 and began collecting a litany of flawless looks, from curvy bobs and smoky eyes to voluminous bouffants and natural curls.

"I used to work as a busgirl in the basement cafeteria of Hudson's department store in Detroit. I tried to copy the mannequins' outfits. In the beginning, I made all the clothes for the Supremes too. Our first manager was actually a pimp, and his girls dressed very well; we tried to copy some of their clothes."

Ross saw the release of her first solo album in 1970, featuring her number one single, "Ain't No Mountain High Enough," and soon she was leading us into the disco era with plenty of glitz and that stunning Afro—which she showed off in electric blue in the 1975 camp classic, *Mahogany*. She also designed many of the clothes for the film, having majored in fashion design and costume illustration.

In 1972, Ross was nominated for an Academy Award for her performance as Billie Holiday in *Lady Sings the Blues*, and she appeared as Dorothy in *The Wiz* in 1978.

She's sported fuchsia feathers, shimmering dresses, and sequined jumpsuits, working with the likes of Bob Mackie, Tom Ford, and Vivienne Westwood. Ross has stunned in feathers, slayed in beaded gowns, and strutted in silk. Mod, bohemian, preppy, or monochromatic—there's no genre she can't easily embody.

Ross created a makeup line with M.A.C. Cosmetics, and released her signature scent, Diamond Diana in 2017, calling it "light enough, yet exquisite enough. . . . I wanted the fragrance to have a little bit of mystery. I wanted it to sing."

Sporting a black-and-white tulle ensemble, she performed at Buckingham Palace for the Queen's Platinum Jubilee in 2022.

She has sold more than 100 million records, and only the Beatles have more hit singles. Ross has earned countless accolades, including the Grammy Lifetime Achievement Award and the Presidential Medal of Freedom, and whether she's singing, acting, or racking up yet another award, she continues to appear effortlessly fabulous along the way.

Julia Sarr-Jamois

"My mum's old Levi's jeans are still a big part of my wardrobe. I love my Gucci fur-lined mules that I wear almost every day and without a doubt my colorful fur coat; the flashier the better!"

She's worked as fashion editor for *British Vogue*, *Wonderland*, and *Pop* and senior fashion editor for *i-D* magazine (where she first interned). She's also contributed to *Vogue*, *Teen Vogue*, *Vogue Japan*, and *Miss Vogue Australia*, and styled for photographers Alasdair McLellan, Boo George, Tyrone Lebon, Paul Wetherell, Jamie Hawkesworth, Ben Weller, and Matt Irwin—to name a few. Suffice it to say, Julia Sarr-Jamois knows her stuff.

"When I first started working as a fashion editor, I think I always knew, like, what my core things that I loved were. For me, it always needed to be a believable character that I was creating. So, think about the character, but also, like, I always make sure, like, 'Would I wear this?' is really important to me, even if it goes into a fantasy world, it still needs to have an element of truth, basically."

Growing up in a colorful childhood home in Brixton, Sarr-Jamois had a textile designer, ceramicist, and vintage fashion aficionado for a mother.

"When I was a teenager, my mother, who also works in fashion, managed to find me an invitation [to the Chanel show] through one of her friends who was working at Lesage. I travelled to Paris from London especially for the event, and I remember spending hours worrying about what I was going to wear! It was a very emotional and exciting experience."

It was around this time that she adopted her signature hairstyle.

"When I was a little girl, I used to wear my hair in braids, but since the age of fourteen, I've embraced my afro. At first I found it difficult to get used to its sheer size, but I've never changed it."

Sarr-Jamois began modeling at age fourteen, and although she's mainly behind the scenes these days, she can still occasionally be found on the pages of *Vogue France*, for instance, wearing Marc Jacobs, Emporio Armani, Louis Vuitton, Balenciaga, Prada, or her mom's old Levi's jeans.

"I like to mix it up, because I really love fashion. Sometimes I want to be all pared-back and chic in black, then the next day I'll wear camo with a fluorescent jumper and a puffer jacket."

Through the years, she's amassed quite the treasury of valued pieces.

"I wish I was a curator, but I'm definitely a magpie about collecting clothes. I just love so many different things and also I think, 'cause my style is quite a mix, like, I like tailoring but then I also love a sequin dress, so the choice is very large for me, which is a problem!"

Combining unexpected elements with a streetwise twist on glamour, Sarr-Jamois has styled for a wide variety of campaigns, including Moschino Cheap & Chic, Topshop, Zara, Sonia by Sonia Rykiel, and Sass & Bide. She finds inspiration on the city streets, especially in London.

"I spend a lot of time watching passersby and I love the fact that nobody judges other peoples' clothes; it gives us all a lot of freedom. It allows me to test out lots of different looks. I often think that I would have had a different relationship with clothes if I had grown up anywhere else. Another strong inspiration for me is Africa. Every trip I take to Dakar, I love the striking, strong colors, prints, and glittery materials. Mixing street style with African prints."

At the end of the day, Sarr-Jamois loves fashion and encourages others to embrace their creativity.

"The most important thing is to wear what you feel like. I don't think you should follow rules."

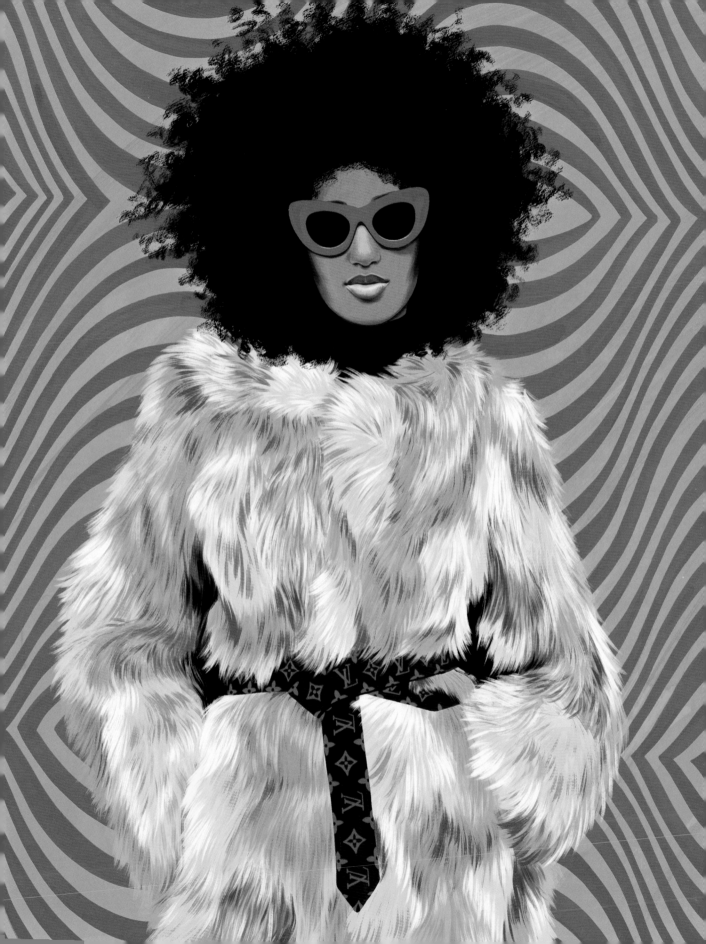

Hunter Schafer

"In some ways, I think [fashion is] escapism. In other ways, I think it's the absolute truth. While it can feel extra to be putting that much time, energy, or thought into your appearance, particularly for trans people, sometimes you're not really yourself until you feel as though you're presenting who you actually are to the world."

Twenty-three-year old Hunter Schafer intended to study design at Central Saint Martins, but thanks to her growing modeling résumé, she was invited in 2018 to audition for a new HBO drama—*Euphoria*.

The Prada muse, runway model, artist, and Gen Z icon—she calls herself a "fashion fucking geek"—earned the role of Jules, taking her career in an unexpected direction that has certainly paid off.

Scouted from Instagram, Schafer has walked runways for Rick Owens, Miu Miu, Dior, and Marc Jacobs, even attending the Met Gala in 2021 in a Prada two-piece set and Evangeline AdaLioryn jewelry.

"I got into modeling because I wanted to be involved in the fashion industry. That was my goal since middle school. I wanted to take a gap year and make some money before going to the next round of school. So, when I kind of figured out that I might be able to model and made the right connections through Instagram and photographers I knew, that became a reality. Modeling for a year taught me a lot. I got very involved in the fashion industry and met a bunch of people who I admired."

Raised in Raleigh, North Carolina, Schafer didn't always feel as comfortable in her skin as she certainly appears now. "It takes a little bit of bravery to step out, to be like, okay, I don't look like anybody else around here. I am making the conscious decision to present myself the way I want to today, and no one's really going to fuck with it, but I fuck with it. And that's all that matters."

One of her favorite designers early on was Alexander McQueen. "When I discovered his collections and the element of performance and how extraterrestrial everything felt, it extended beyond the boundaries of real life. That, I think, is all I was looking for at the time, and it continues to be something I searched for through fashion and media."

Who else does she like to wear? Schafer is a fan of "some of the newer designers, like Luar, Vaquera, and No Sesso. I really love Lou Dallas. [Designers] who are taking a more DIY approach or a less conventional beauty approach and have diverse casting with diverse bodies are really exciting, because I think that's where we are headed and what I'm excited to see on a runway."

She's appeared in *Harper's Bazaar* in Chanel, Christian Louboutin, Balenciaga, Dior, Celine, Stella McCartney, Prada, and Louis Vuitton but knows haute couture isn't for every occasion.

"I've gone clubbing in an oversized T-shirt and my Dr. Martens and little tiny shorts, and that's felt good for the night."

Even with her new acting endeavors, Schafer has no intention of abandoning her first calling.

"I still love fashion, and I definitely would like to keep interacting with that world. As far as doing all four fashion weeks and going to every casting that I can, maybe not that again. But I think it's kind of exciting to be able to interact with it in a way that isn't relying on necessity or money and more because I love it, which goes back to the roots of why I got into it in the first place."

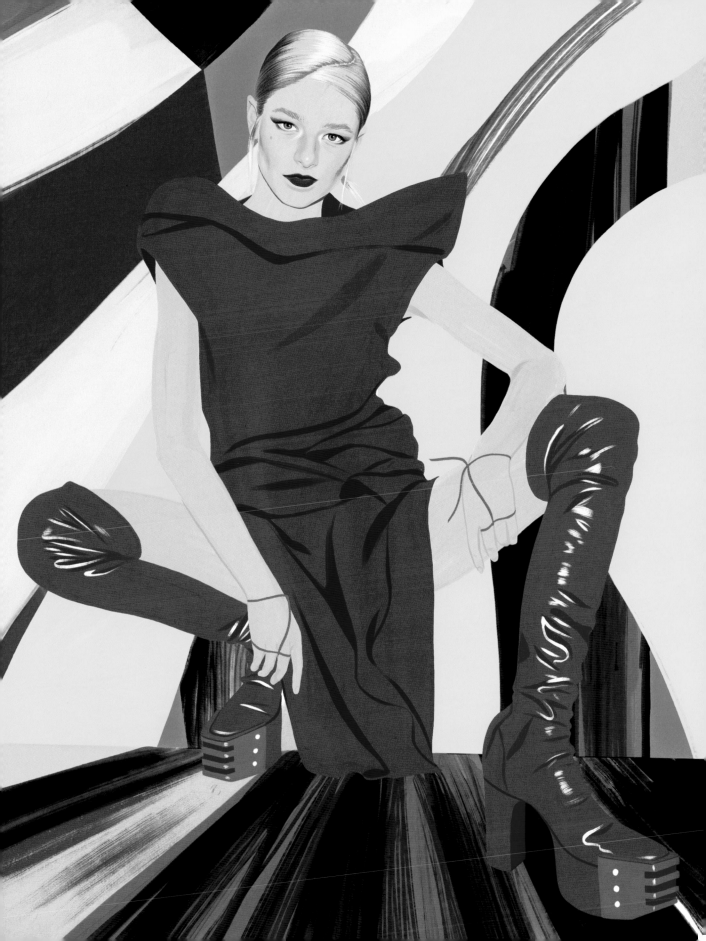

Jean Seberg

"What seems very glamorous when you see it—for an unusual example, an actress in a mink coat or something and posing very beautifully with a leg sticking out or something, that she spent hours under hot lights and with a hairdresser and with a makeup man getting ready for this photograph and even trying to look glamorous and trying to appear relaxed—is in a way work too, but there's more to it than just phony glamour too, isn't there?"

More than forty years after her untimely death at age forty, Jean Seberg is still providing plenty of fashion inspiration for the French style—or at least an American in Paris.

Although she hailed from Marshalltown, Iowa, Seberg spent enough of her career in France to link her to the country and its fashions forever.

She got her start in film when her high school drama coach entered her name in a talent competition, beating out eighteen thousand other girls for the lead role in Otto Preminger's *Saint Joan*.

The film was widely publicized, and Seberg said, "I took my acting lessons before the largest audience in the world."

Of course, the period piece offered few opportunities for fashion moments, and yet Seberg made an impression with her close-cropped hair and spartan tunics, initially becoming known more as a beauty than a gifted actress.

The seventeen-year-old's performance, unfortunately, was widely criticized—not to mention the accident on set in which Seberg actually received burns at the stake—but that didn't stop her from moving forward, becoming a significant player in the French New Wave scene.

"I have two memories of *Saint Joan*. The first was being burned at the stake in the picture. The second was being burned at the stake by the critics. The latter hurt more."

In her next film, *Bonjour Tristesse*, Seberg wore costumes designed by Hope Bryce—an Oxford blue men's tailored shirt tied at the waist, and elegant black cocktail dress, and a square-necked swimsuit in buttercup yellow.

But it was her 1960 appearance in *Breathless* that turned Seberg into a bona fide fashion icon, inspiring women across Europe to replicate her style. Within the film, she wore cigarette pants, stylish flat shoes, and a boat-neck striped mariner shirt. After its release, popularity rose for slouchy Breton tops, knit sweaters with Peter Pan collars, and Seberg's signature blonde pixie cut. Eventually her influence spread farther, popping up on magazine covers and billboards across the globe.

At thirty-five, Seberg wore long dresses and her hair in a mature knot: "Everyone keeps telling me my legs are bad." She said, "I'm in a funny age bracket for an actress. I'm not young enough to play the ingenue anymore, and I'm not old enough to get into the character thing. It is perhaps for your own sanity that you go into other areas."

Seberg often sported minimal makeup—subtle peachy blush and upper eye liner—and she was fond of Yves Saint Laurent, Courrèges, Givenchy, and Ungaro.

Despite the early criticism, the actress eventually earned a Golden Globe nomination for her performance in *Lilith* with Warren Beatty.

"All those small films in France gave me a decent name again. I was no longer a pariah."

Her legacy in fashion is solid and long-lasting, all dressed in cat-eye sunglasses, androgynous white T-shirts with rolled sleeves, tailored trousers, and a fedora hat.

I'm going to live this year as if it were my last," Seberg said on New Year's Eve 1973, six years before her tragic death. "I like to have friends laughing around me, and I like good food and good wine—so what if I'm the only one who can afford to pick up the check?"

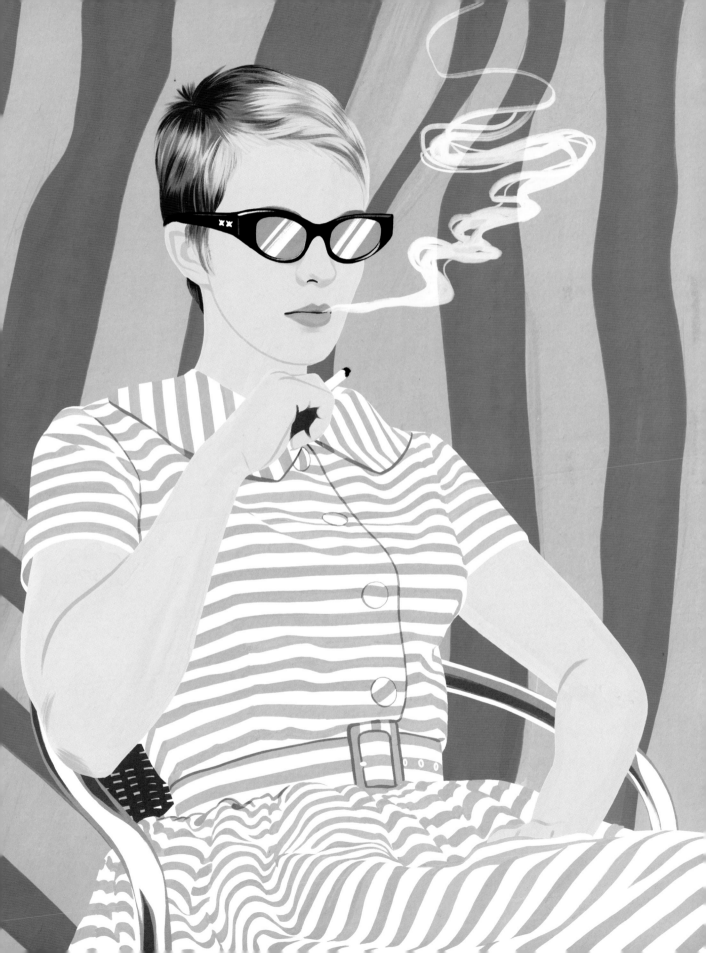

Chloë Sevigny

"My wardrobe is vast and exhaustive and a little embarrassing."

The year was 1994 when the *New Yorker* dubbed a nineteen-year-old Chloë Sevigny "the coolest girl in the world"—a moniker she's been living up to ever since, whether she likes it or not.

"I guess people think of me as a strong individual, and strongly individual. I don't want to say it outshines my acting, but it's always been: 'Oh, she's the fashion girl, she's the New York girl,' instead of, 'Oh, she's the actress who's done a string of very different, diverse, odd characters.'"

But Sevigny has done plenty to prove her range in acting, beginning with her role in *Kids* after she met writer-director Harmony Korine in Washington Square Park, and appearances in music videos for The Lemonheads and Sonic Youth.

"That video kind of set the tone for the rest of my career. [laughs] Playing a girl on the street . . . It paralleled a bit of what was to come in my life and even what was happening around us then. The storyline of the video matched what was going on in fashion at the time."

Since then, her career has grown to include more than eighty acting credits for television and film, including *Boys Don't Cry*, *Big Love*, and *The Girl from Plainville*; she has dabbled in writing and directing as well.

Sevigny's presence in fashion, on the other hand, began when she interned for *Sassy* magazine at seventeen, where she was known for her corduroy overalls and posed in style spreads for the publication.

"I grew up thrifting with my mom and it was a thing we could do together. Instead of sending me to the playground she would bring me to the Yellow Balloon thrift store in Darien, Connecticut, where I grew up. It's just something that was ingrained in me and still, that's mostly all I buy. I can rarely think of instances [where] I buy brand new clothing."

Sevigny often works with stylist and friend Haley Wollens; she has posed for Miu Miu and Kenzo, created several collaborations with Opening Ceremony, and was considered the muse for nineties cult label X-Girl, designed by Kim Gordon of Sonic Youth.

"[My style] used to be a bit louder or a bit more over doing it, and now it's streamlining a little. I'm still into the whacky chunky shoe and whatever, but I feel like it's not as loud, maybe."

Still, Sevigny often has a bit of a love-hate relationship with fashion and how it's shaped her career.

"Fashion is a big part of me and it's allowed me a lot of freedom in my life, especially with my first love, which is film. I think people in the know, know that I don't work with a stylist for the authenticity. And lots of friends and lots of people in the industry . . . see my down time and how I really dress, and they feel a comfort there. And I don't know, the magazines just latched onto me at a young age I think, and I've kind of been something people didn't let go of."

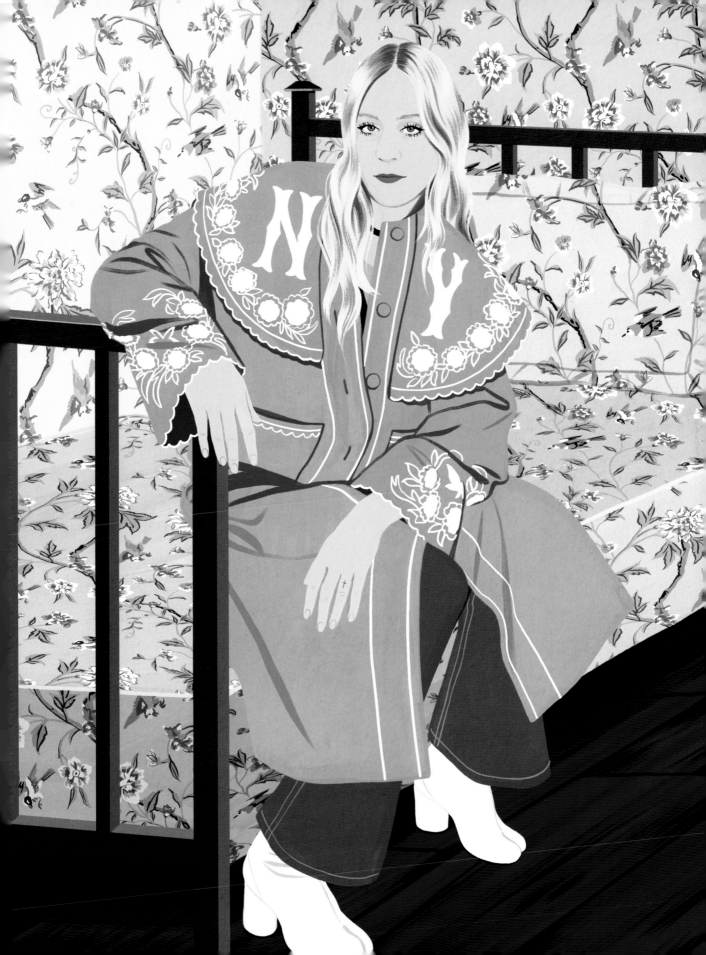

Harry Styles

"There's so much joy to be had in playing with clothes."

In the public eye since age sixteen, Harry Styles has known the intense scrutiny of fans, followers, and media for more than a decade of his young life.

Finding stardom as a member of global boy band sensation One Direction, after the group went on hiatus, Styles found expanded success as a solo artist and actor, appearing in films like *Dunkirk* and *Don't Worry Darling*. He recently completed shows for fifteen consecutive nights at Madison Square Garden, joining the ranks of Billy Joel and Phish in receiving a banner at the venue. In a nod to the singer's fashion preferences, on the final night of his residency, every seat had its own feather boa.

Very much a lightning rod for opinions related to his fashion choices, Styles seems to shrug off the naysayers, embracing what works for him. This entails plenty of Gucci—including a bright pink fur coat, strawberry T-shirt, and leather single-breasted suit—as well as Saint-Laurent, Givenchy, and Bode, and don't forget the pearls.

Gracing the cover of *Vogue* as the first solo male to do

so, Styles spoke to the gender-fluidity of his fashion choices. "I'll go in shops sometimes, and I just find myself looking at the women's clothes thinking they're amazing. It's like anything—anytime you're putting barriers up in your own life, you're just limiting yourself."

His love of fashion knows no bounds. "There's so much joy to be had in playing with clothes," he said. "I've never really thought too much about what it means—it just becomes this extended part of creating something."

Very little seems off-limits when it comes to expanding the limits of Styles's fashion, be it a JW Anderson jumpsuit at Rockefeller Plaza, Marc Jacobs womenswear at the Brit Awards, or rainbow sequins in front of Coachella's hundred-thousand festivalgoers.

Styles easily pulls off a sophisticated black suit when the situation warrants, but it's his playful ensembles from the red carpet to the stage that capture endless attention every time he steps foot in front of a camera or crowd.

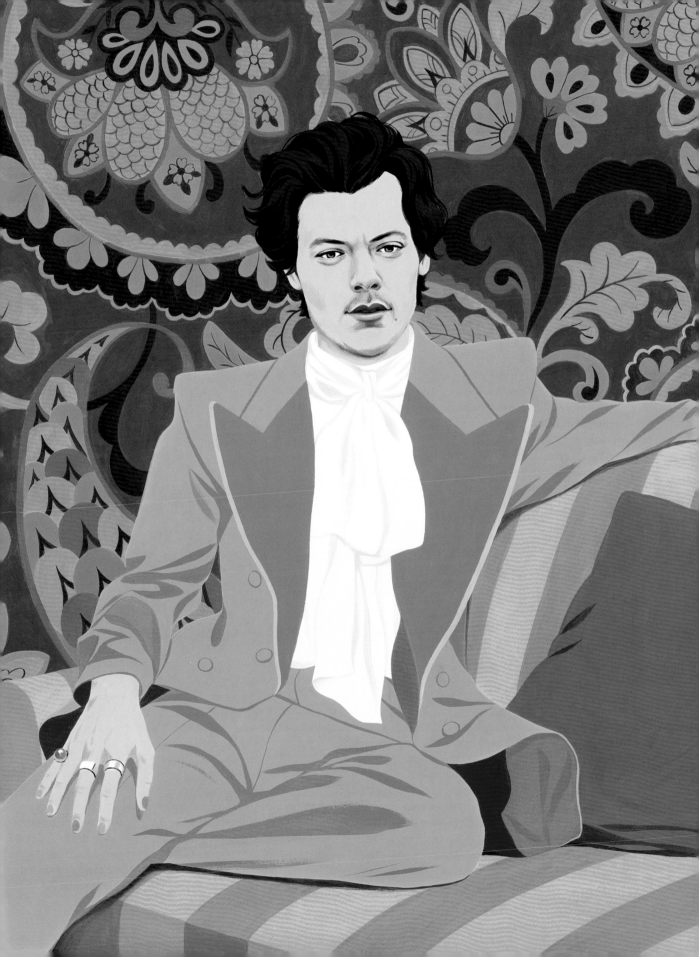

Anna Sui

"I love getting dressed up. I come to the office every day with a dress and makeup and jewelry and boots. I'm dressed like I'm on the runway every day."

Where does a trend come from? It may not be one designer, one magazine, or one wizard behind a curtain, but time and time again Anna Sui has proven she has a hand in guiding the direction of fashion, influencing and inspiring the next popular looks.

Born in a Detroit suburb in the sixties, Sui fostered a passion for fashion from a very young age. "I came to New York when I was about four, and I was the flower girl at my aunt and uncle's wedding. So when I got back to Michigan, I told my parents that when I grow up, I want to move to New York and become a fashion designer. It took me a lot of time to figure out what that meant and how to do that, and one of the things was fashion magazines. . . . I saw an article in *Life* magazine about two young ladies who went to Parsons School of Design, and I thought, *Okay, I have to go to Parsons because that's where designers go.*"

After two years at her dream school, Sui left to go pro, designing for sportswear brand Glenora and styling for photographer Steven Meisel.

"You have to focus on your dreams, even if they go beyond common sense. How could this young girl from the suburbs of Detroit become a success in New York? It was always that dream."

Sui showcased her first collection of six pieces at a New York trade fair, where a Macy's buyer took notice. Continuing to design out of her apartment for the next ten years, Sui received encouragement from supermodel Linda Evangelista and others to take the next step. She brought her first collection to the runway in 1991 and one year later opened a boutique in Soho that specialized in Victorian punk, later expanding her expertise to fragrance, cosmetics, footwear, accessories, and interior design and décor.

Her own Greenwich village apartment is an extension of her unique, visual aesthetic. The interior is an all-encompassing, layered, patterned, colorful mix of elements that includes Chinese cloisonné screens, de Gournay wallpaper, custom murals, and Victorian papier-mâché chairs. The combination is distinctively Sui.

Sui has described her style as "the concept to sell to rock stars and to those who go to rock concerts," finding plenty of inspiration in vintage styles and collecting ideas from her travels to employ when the time is right.

"I love shopping, and I love fabric. So when I see the fabric, I can almost see the clothes. So I'm fortunate enough to be able to create a lot of my own fabrics and prints and things, but that wasn't always the case. I'd have to find it and then I'd have to envision what it was going to be, but now I can kind of create it."

These days, Sui has more than fifty boutiques worldwide, with her designs available for sale in eight countries. Sui's celebrity clientele has included Cher, Drew Barrymore, Gigi and Bella Hadid, and Madonna. She has produced eighty-four collections since 1991, taking up residence in New York's famed Garment District for the past thirty-eight years.

"There's a lot of excitement, and it reminds me very much of when I first started—that they're just so resourceful, figuring out how to get textiles and having somebody sew these small lots of clothes and gradually trying to grow their business."

Sui's mantle of awards includes the CFDA Perry Ellis Award for New Fashion Talent and CFDA Geoffrey Beene Lifetime Achievement Award, and her work has been exhibited at the Fashion and Textile Museum, London.

"I still really enjoy shopping and looking and discovering new things, and just one thing always leads to another. Same with the research. I love learning about new things, and I love learning about them and then talking about them or showing them off, and that's what, to me, is what my creation is."

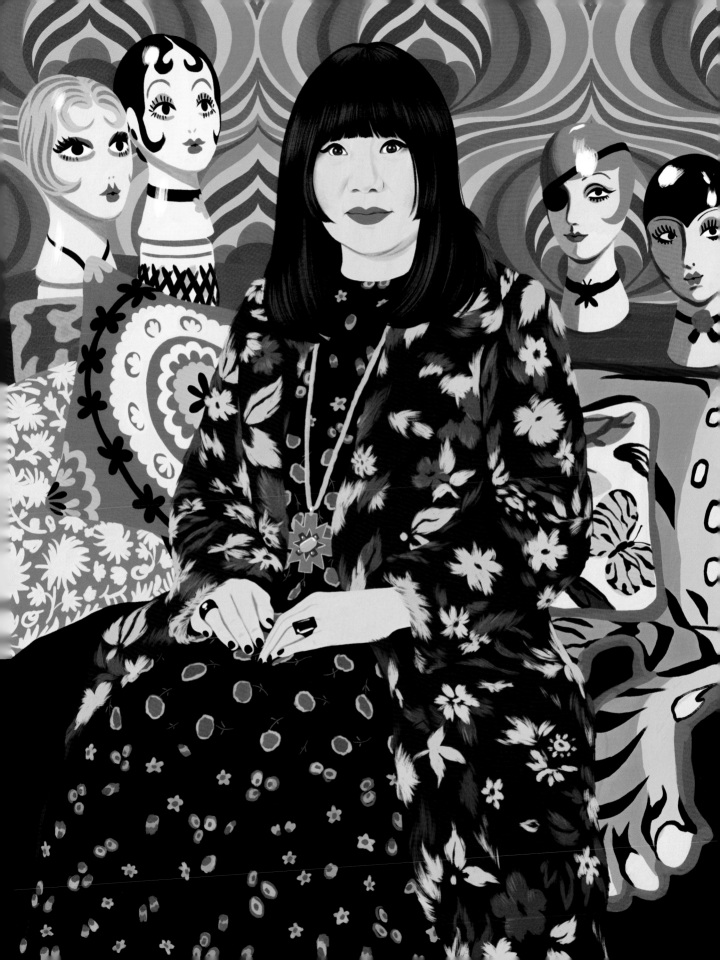

Tilda Swinton

"There are very few clothes that really move properly, in relation to the body like [Haider Ackermann's] do—that feeling of them being designed for movement; designed for the body; for the gesture."

Tilda Swinton is a chameleon. All at once instantly recognizable and successfully able to disappear into a role, she is undoubtedly one of a kind.

At sixty-one, she has graced screens for more than three decades, making a name for gender-fluid style and androgyny since her 1992 breakout performance in *Orlando*—playing a character who transforms into a woman after hundreds of years as a man.

"I would rather be handsome . . . for an hour than pretty for a week," Swinton told *W* magazine, citing her influences as David Bowie and her father, Maj. Gen. Sir John Swinton.

Known for an air of mystery and even alien-like appearance, Swinton said that when it comes to fashion, "I just follow my nose. It's as simple as that."

Whether it be a controversial black silk dress at the 2008 Oscars, a lime-green blazer at the Venice Film Festival,

or a soft white goddess gown at the SAG awards, Swinton's style never falls victim to five-minute trends nor boring predictability.

At the 2021 Cannes Film Festival, she represented five of the year's films, each with an eye-catching look to accompany it. For *The French Dispatch* it was a cool-blue blazer and matching cigarette pants by Haider Ackermann standing alongside fellow fashion icon, Timothée Chalamet.

Working with designers including Lanvin, Chanel, Valentino, and Vionnet, Swinton's red-carpet looks over the years have been anything but boring. Featuring an array of eclectic suits, figure-flattering gowns, and her iconic short hair—often blonde or reddish with plenty of wave and pomp—Swinton's fashion appears to be as timeless as her age-defying presence.

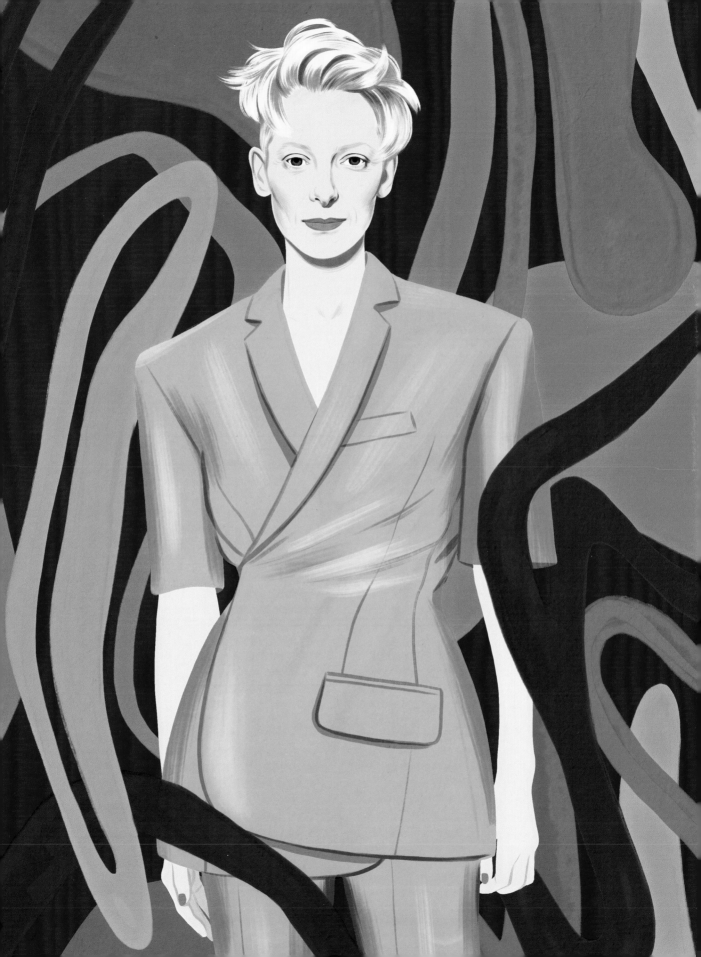

André Leon Talley

"I don't live for fashion. I live for beauty and style."

"I never thought I would have the career and life that I had; I never had that kind of ambition or drive. My life has been because people saw something in me. I didn't lobby or stand in line or scheme to get to these places. They all came to me because of my talent and aura and persona and knowledge. Everything has come to me, somehow or another, because of who I am. And hopefully I am someone people respond to for a sense of knowledge and knowing the history of fashion, style, and culture."

There's no question that people responded to André Leon Talley—with his larger-than-life persona—throughout his life and career. He grew up in his grandmother's home in Durham, North Carolina, where even as a child he found respite in the pages of his favorite magazine. "[*Vogue*] was my gateway to the world outside of Durham. It was the world of literature, what was happening in the world of art, what was happening in the world of entertainment."

Talley studied French literature at Brown University and earned his start as a receptionist for Andy Warhol's *Interview* magazine before climbing the industry ladder to become editor-at-large for *Vogue* magazine, the place he called home for decades, with an interlude at *W* magazine in Paris.

"I got here because I had knowledge. As Judge Judy always says, 'They don't keep me here for my looks.' They keep me here for my power. Because knowledge *is* power."

Of course, serving as *Vogue*'s first Black male creative director didn't come without its challenges.

"How did I overcome that kind of racism? I internalized and struggled with it . . . I ignored it at the time . . . I had family and faith and [the late former *Vogue* editor] Mrs. Vreeland and [the late former *Women's Wear Daily* editor in chief] Mr. Fairchild."

His life and work have been chronicled thoroughly as deserved, through the documentary *The Gospel According to André* and his own book, *A.L.T.: A Memoir*, although the general public probably knows him best from his stint as a judge on *America's Next Top Model*, always serving chic in his custom capes and caftans.

"I'm a big, big guy of great girth and people think I look like maybe my clothes don't look that important, but I have taken great time and [done] fittings for my capes and caftans made by the great designers."

An international icon, Talley styled Michelle and Barack Obama during their time in the White House and was considered a "close confidant of Yves Saint Laurent, Karl Lagerfeld, [and] Paloma Picasso." He leaves a legacy of kindness and inarguable fashion expertise.

Although his mark on the world undoubtedly speaks for itself, when asked how he wanted to be remembered, Talley simply said, "He helped others to see. He helped others to live."

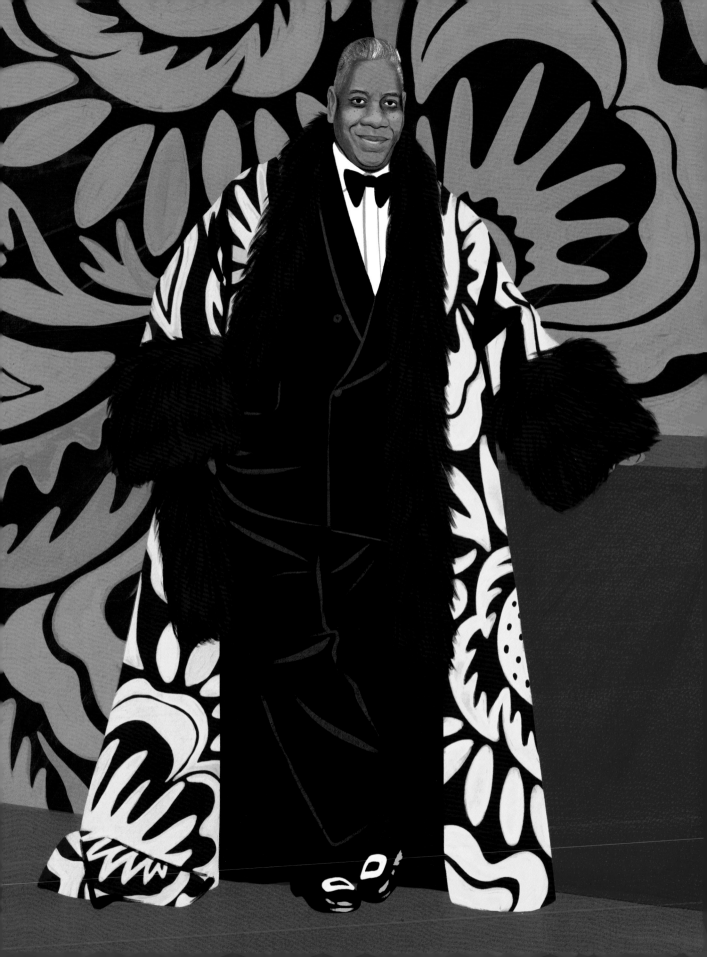

Tyler, the Creator

"The way the light hits in LA just makes everything seem so saturated. It's not dense or cluttered with people so I guess it just allows you to just dress in these vibrant colors."

After entering the music industry about fifteen years ago as part of the Odd Future collective, hip-hop artist Tyler, the Creator began designing merch for the group out of his grandmother's house that would come to be sold in more than three hundred stores and a dedicated Odd Future shop.

But after striking out on his own (he's released six studio albums), Grammy-winning musician Tyler, the Creator advanced to the next stage of his fashion journey, launching apparel brands Golf Wang in 2011 ("With Golf Wang, it's like, man, we gotta make the illest T-shirts, the illest hoodies, the illest utility vest") and Golf Le Fleur in 2017 ("Le Fleur is, you know, sweaters, slacks . . .").

"I never liked making Tyler, the Creator merch. I never liked it. I never liked putting my face on merch. I've done it two or three times probably. But when people call Golf Wang merch, it's like . . . These are actual clothing pieces. It's a store. It's ran like a line. Don't call it merch."

He doesn't participate in Paris Fashion Week and rarely graces a red carpet, but he does take hands-on participation in his clothing lines very seriously.

"I still edit the lookbooks. I still make sure that the black and shadows are right. Like I still give a fuck about all of it."

Tyler, the Creator relies on a trusted team to help him bring to life his visions, including jewelry designer Alex Moss.

"I want every jewelry piece to be on point. I want every shirt I wear to be on point. So to find someone in their world that cares about their craftsmanship as much as Alex does is ill."

Other collaborations include working with Converse and Lacoste and a Gucci campaign with A$AP Rocky and Iggy Pop. "I liked what Alessandro [Michele] was doing. When he came to Gucci, it just kind of lined up to what my taste was molding into. And I just loved how the photos and things were shot. It had, like, moments where it was like, oh, that's some shit I would've done."

Tyler, the Creator's path to fashion designer may not have been traditional, but his dedication to the venture is genuine.

"I don't know what I'm doing. I don't know much about color theory. I never went to school for it. So I don't know the rules. I just know what I think looks good and what I don't like. For example, I hate red, brown, and purple together so fucking much. It's the worst color combo of all time."

At only thirty-one years old, Tyler, the Creator is leaving plenty of room to explore new avenues in the future. "I might do a rock album. I mean, I probably won't, but who knows. Maybe in another life I have a blue mullet. That is one thing I'll never get to achieve."

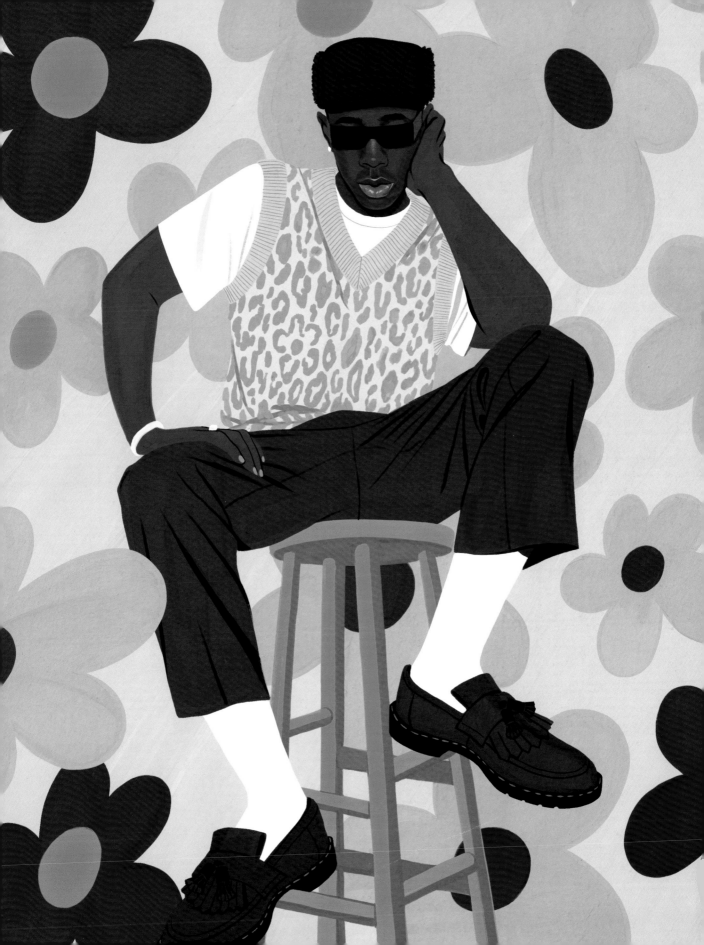

Diana Vreeland

"Style: All who have it share one thing—originality."

Diana Vreeland, born September 29, 1903, grew up in Paris and New York, and despite feeling like an "ugly little monster" in her mother's eyes, she would grow to become the arbiter of beauty for countless devoted readers and industry professionals.

Vreeland opened a lingerie boutique in London in the twenties, counting Wallis Simpson a client. A few months after moving back to New York with her husband, Vreeland wore a white lace Chanel dress with white roses in her hair to the St. Regis Hotel. There she met Carmel Snow, the editor in chief of *Harper's Bazaar*, who offered her a job the very next day.

"But Mrs. Snow, except for my little lingerie shop in London, I've never worked. I've never been in an office in my life. I'm never dressed until lunch," she said.

"But you seem to know a lot about clothes," Mrs. Snow responded.

"That I do. I've dedicated hours and hours of very detailed time to my clothes."

Vreeland went to work at *Harper's Bazaar*, writing the "Why Don't You?" column beginning in August 1936 and working as fashion editor.

"We saw every corset, every belt buckle, every piece of new cloth. We felt the rhythm, the music, the whole tango. One was editor of *all* clothes."

She is known for putting the first bikini in the magazine. When staffers were dazed by the exposure of skin, Vreeland said, "With an attitude like that, you keep civilization back [a] thousand years."

Vreeland collaborated with the likes of photographer Richard Avedon (whom she originally referred to as "Aberdeen," much to his annoyance) for nearly forty years and gave André Leon Talley his start.

She remained at *Harper's Bazaar* until January 1963, when she became editor in chief of *Vogue* magazine. There, the Empress of *Vogue* developed a reputation for decisive action, a dependable routine (her limo arriving in late morning, she'd step out in head-to-toe black with a flawless manicure and perfectly immovable hair), and plenty of wise aphorisms:

"Elegance is innate. It has nothing to do with being well dressed."

"I loathe narcissism, but I approve of vanity."

"You don't have to be born beautiful to be wildly attractive."

"A little bad taste is like a nice splash of paprika."

In 1971, Vreeland left *Vogue* and at sixty-nine years old signed on at the Costume Institute of the Metropolitan Museum of Art in 1973, beginning with a retrospective of Balenciaga's clothes.

Vreeland was known for decorating her home and offices with bright red paint—at least one had a leopard-skin rug.

"Red is the great clarifier—bright and revealing. I can't imagine becoming bored with red—it would be like becoming bored with the person you love."

Vreeland passed away on August 2, 1989, leaving a legacy in fashion that is still very much remembered and honored today.

"A new dress doesn't get you anywhere; it's the life you're living in the dress, and the sort of life you had lived before, and what you will do in it later."

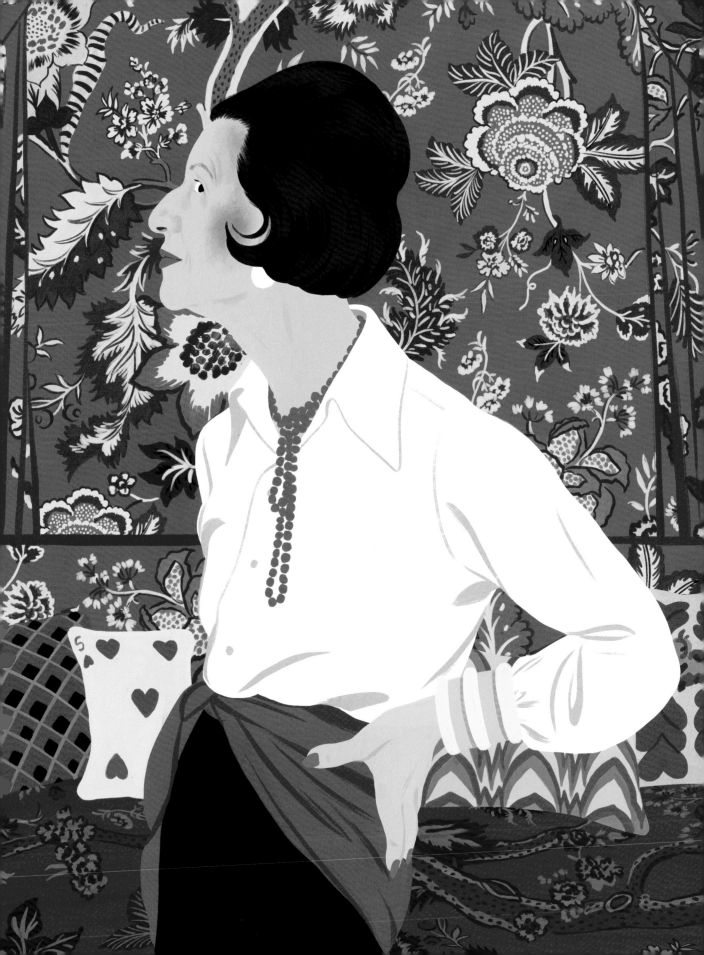

John Waters

"You don't need fashion designers when you are young. Have faith in your own bad taste. Buy the cheapest thing in your local thrift shop—the clothes that are freshly out of style with even the hippest people a few years older than you. Get on the fashion nerves of your peers, not your parents—that is the key to fashion leadership."

Somewhat of a quirky renaissance man, John Waters is a filmmaker, actor, writer, and artist, known for his cult films and sense of surrealism.

Growing up in the suburbs of Baltimore, Waters developed a friendship with Harris Milstead (later known as Divine when she inspired and starred in several Waters films) and had an interest in puppets (motivated by the film *Lili*). He also took great inspiration from *The Wizard of Oz*, one of the first films he saw in theaters.

"[Margaret Hamilton] led to my whole belief, in all my movies that I made, that basically my heroes and heroines are sometimes the villains in other people's movies. . . . I realized that I was never going to be like the other kids, that I wasn't going to fit in, but it didn't bother me. It was a secret society to know that the villains were just much more fun."

He began his career making short films in Baltimore, an art form he continued after he was kicked out of NYU for marijuana in 1966. Four years later he would first grow his signature pencil mustache. "I dressed like a hippie pimp," he said. "I had long hair and wore ridiculous thrift-shop shirts. The mustache just went along with my sleazy look." He's had it ever since, with no intention of abandoning the Maybelline-aided style. "I bet if I shaved it off now there would be a mark there, or a scar, because I've had it for so long. Why would I get rid of it now?"

Waters continued to make films—some campy, some trashy—eventually steering somewhat more mainstream with movies like *Hairspray* (later developed into the Broadway musical), *Cry-Baby*, and *Serial Mom*.

In the 1990s he turned to the fine arts, creating photography and installations that have been exhibited internationally. He's also written several books.

No matter what form his art has taken over the years, his sense of style has been present throughout. He has walked a Paris runway for Rei Kawakubo, inspired Jeremy Scott's 2016 show, and appeared as the face of Saint Laurent in 2020. A slew of nicknames have been bandied about for his overall oeuvre—"Pope of Trash," "Prince of Puke," and "Duke of Dirt" among them.

And don't forget his own appearance. "Fashion is very important to me. My 'look' for the last twenty years or so has been 'disaster at the dry cleaners'," he wrote in his 2010 book, *Role Models*. His go-to look has long been vibrant and colorful suits, including his favorite cotton-candy pink ensemble. "Most of the ones that are my favorite, a jury would let off the person that beat me up for wearing them."

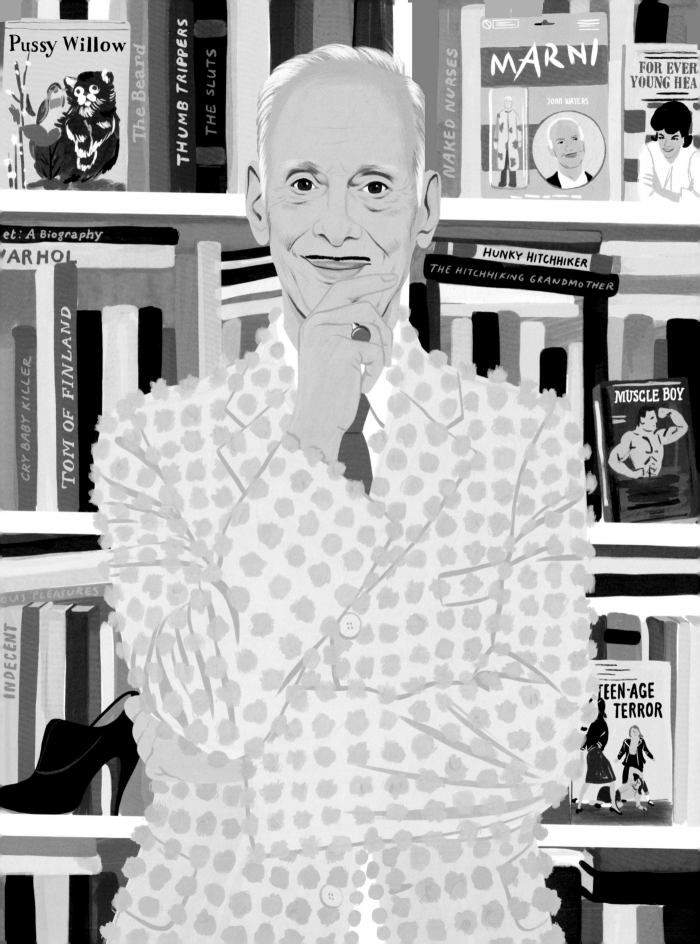

Vivienne Westwood

"The thing about punk was that it was an amazing look. It was probably the most glamorous fashion that's ever existed, and I think that's what we have to really remember. It was just outrageously brilliant and that's that."

At eighty-one years old, Vivienne Westwood was far more concerned about saving the planet than she was about designing the next trendy look.

"I've always had a political agenda. I've used fashion to challenge the status quo."

As the mother of punk, it's rather fitting that Westwood wouldn't remain static in her evolution as a designer.

Born in Derbyshire in 1941, Westwood moved to London at seventeen, working as a teacher before beginning her legendary career in fashion, opening a shop with Malcolm McLaren that went by various names over the years. Its most well-known iteration, of course, being SEX, which, in collaboration with the Sex Pistols, became the center of the punk fashion scene, selling bondage gear, platform shoes, and slogan T-shirts.

"It changed the way people looked. I was messianic about punk, seeing if one could put a spoke in the system in some way."

Westwood presented her first full fashion collection with McLaren in 1981, beginning to veer away from the punk aesthetic which had first put her on the map.

"I lost interest in punk. I realized subversion is in ideas and ideas come from culture."

Instead, she embraced styles from the seventeenth and eighteenth centuries.

"I tried to prove by example that the past is as relevant today as when it was invented, ideas are as relevant today as when they were invented—and I proved it by copying historical clothes. No designer had ever done this before, they'd been inspired by historical clothes, but I actually copied them."

In 1988, Westwood met Andreas Kronthaler; they were married more than thirty years, and he served as her creative director, beginning in 2016.

"Andreas joined me at a time when I had just reworked the eighteenth-century corset, the crinoline, the ultra-high platform shoes, and English tailoring."

For her part, she was happy to pass the reins to such a capable partner.

"Andreas is doing a great, great job. He gets me dressed, for this shoot too [in *GQ* magazine]. I don't have to worry about any of that, because I want to use every second I can to spread my message, to fight climate change. He's helping me in every possible way."

With five decades in the industry, the Dame of the British Empire built a solid legacy, counting an endless list of famous faces among her clientele, including Dua Lipa, Sarah Jessica Parker, Gwen Stefani, Bella Hadid, and Harry Styles.

"Fashion is something we truly need, unless you think we should go around naked—we're quite near to that at the moment, with vests and all that stuff. I think it's incredibly important to maintain the fashion skills that we still have."

In the final chapter of her life, what mattered most to Westwood was ensuring a bright future for the industry and humanity as a whole.

"What I want now is a sustainable fashion business. The definition of that is not just a question of no plastic; what the designer wants is beautiful clothes at the right price. Buy less, choose well, make it last."

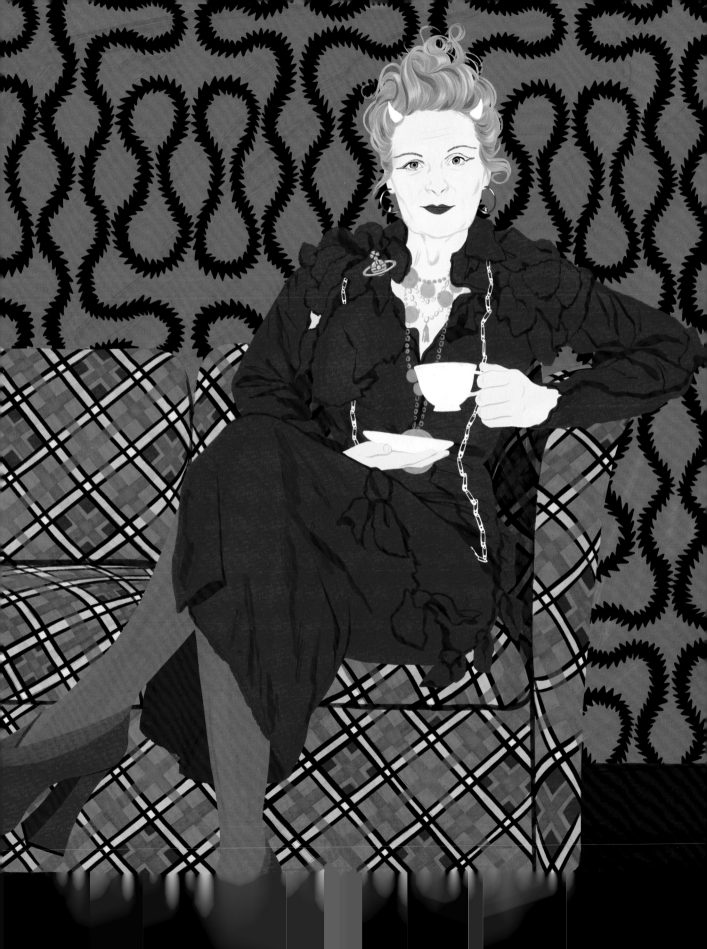

Zendaya

"That's the point of fashion and style: not everybody is supposed to like it . . . and if you don't like it, that's fine, everyone's entitled to their opinions."

Starring in not one but two Disney series as a young woman, Zendaya (Coleman) has been working as a full-time actor since she was only thirteen years old. (Growing up in Oakland, her mom worked for the Shakespeare Festival, introducing her daughter to the draw of theater.) Since then, her résumé has expanded to include major feature films like *The Greatest Showman*, the *Spider-Man* franchise, and sci-fi masterpiece *Dune*, as well as the lead role on HBO's *Euphoria*—for which she became the youngest woman to win an Emmy for outstanding lead actress in a drama series.

And along with her acting success, Zendaya has earned ample opportunities to venture into the fashion industry, serving as the face of Lancôme, Bulgari, and Valentino, as well as inspiring a Barbie doll in her likeness who appears in the stunning Vivienne Westwood gown Zendaya wore to the Academy Awards in 2015.

"When I was little, I couldn't find a Barbie that looked like me, my . . . how times have changed."

In 2019, Zendaya teamed up with Tommy Hilfiger to create a capsule collection, Tommy x Zendaya, inspired by the 1970s and celebrating diversity.

"The most important thing to me is that these clothes feel timeless and whoever puts it on feels powerful and confident. I really appreciate how Tommy and his entire team really allowed Law [Roach] and I to have complete creative freedom. They gave us the support we needed to create our vision, and they executed it perfectly."

Roach is Zendaya's long-time stylist; they met when she was only fourteen and bonded over a shared fondness for a vintage YSL bag.

"I've always loved fashion, and I've found that it's an incredibly fun way to express myself. I definitely have a strong point of view on what I'm wearing and love to collaborate with my stylist, Law."

As she expands her career, Zendaya is crafting a carefully curated wardrobe that she intends to rely on for many years to come.

"I want to reuse my clothes. I want to be able to wear that dress again when I'm forty and be like, 'This old thing?' Really finding good vintage pieces that I want to invest my money in."

Zendaya has appeared on plenty of magazines, including the covers of *Interview* magazine and *Vogue*. For the *Vogue* shoot, she posed in Marni, Olivier Thesykens, Marc Jacobs, Richard Quinn, and Loewe, among others.

Moving forward in her career, Zendaya doesn't require a rigid plan (although she's interested in directing) but hopes that financial stability will allow her flexibility in the projects she chooses.

"Be true to yourself. Knowing who you are and what you stand for is important, but don't be afraid to evolve. Always try to focus on creating and doing things that genuinely make you happy, things that feel good in your gut and your heart, and you really can't go wrong."

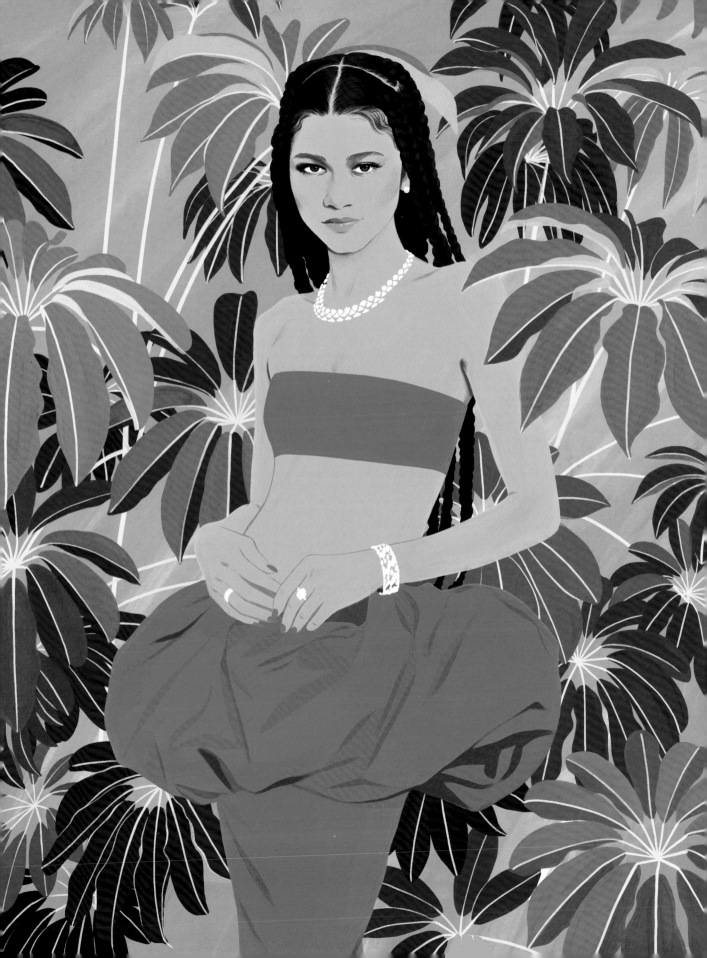

Bibliography

WES ANDERSON

Bateman, Kristen. "Cinematic Style: The Chicest Wes Anderson Fashion Moments." *Harper's Bazaar*, August 7, 2015, https://www.harpersbazaar.com/culture/film-tv/a11740/chicest-wes-anderson-fashion-film-moments/?utm_campaign=arb_ga_har_md_pmx_us_urlx_17944069560.

Desplechin, Arnaud. "Wes Anderson." *Interview*, September 30, 2009, https://www.interviewmagazine.com/film/wes-anderson.

Wolf, Cam. "*The French Dispatch* Red Carpet Put Every 2021 Vibe on Display." *GQ*, July 13, 2021, https://www.gq.com/story/the-french-dispatch-red-carpet-style.

IRIS APFEL

Conner, Megan. "Iris Apfel: 'People Like Me Because I'm Different.'" *The Guardian*, July 19, 2015, https://www.theguardian.com/global/2015/jul/19/iris-apfel-interview-designer-fashion-film.

"Iris Apfel Has a Century's Worth of Advice on How to Define Your Own Style." *Vogue*, Accessed January 2, 2023, https://www.vogue.com/sponsored/article/iris-apfel-has-a-centurys-worth-of-advice-on-how-to-define-your-own-style.

Sciortino, Karley. "My Beauty: Iris Apfel." MAC Cosmetics, Accessed January 2, 2023, https://www.maccosmetics.com/culture/my-beauty/iris-apfel.

ERYKAH BADU

Bakare, Lanre. "'I'm Not Sorry I Said It': Erykah Badu on Music, Motherhood, and Wildly Unpopular Opinions." The Guardian, May 24, 2018, https://www.theguardian.com/music/2018/may/24/erykah-badu-interview.

Cristobal, Sarah. "'I'm My Own Audience': Erykah Badu on the Joy in Dressing for Yourself." *InStyle*, July 18, 2022, https://www.instyle.com/celebrity/erykah-badu-fashion-closets.

Satenstein, Liana. "Erykah Badu on Walking Her First Runway for Vogue World." *Vogue*, September 13, 2022, https://www.vogue.com/article/vogue-world-runway-erykah-badu-interview.

DAVID BOWIE

Tashjian, Rachel. "Kansai Yamamoto Designed David Bowie's Costumes—and Was a Legendary Designer in His Own Right." *GQ*, July 27, 2020, https://www.gq.com/story/kansai-yamamoto-bowie.

Valenti, Lauren. "Here's What David Bowie Kept in His Makeup Bag." *Vogue*, September 16, 2022, https://www.vogue.com/article/david-bowie-ziggy-stardust-beauty-makeup.

White, Ben. "David Bowie & Mos Def: The Style Council." *Complex*, January 11, 2016, https://www.complex.com/music/2016/01/david-bowie-mos-def-2003-cover-story.

THOM BROWNE

Florsheim, Lane. "Thom Browne Can Envision an Entire Season in 5-10 Minutes." *The Wall Street Journal*, September 5, 2022, https://www.wsj.com/articles/wsjmagazine-com-thombrownemmm-11662129687.

Heller, Nathan. "After a Stellar Paris Show, What's Next for Thom Browne? Heading Up the CFDA." *Vogue*, October 11, 2022, https://www.vogue.com/article/strong-suit-thom-browne-interview.

Yotka, Steff. "Who Is Thom Browne, the Man Behind the Suit?" *Vogue*, January 11, 2018, https://www.vogue.com/article/thom-browne-interview-career-personal-life.

TIMOTHÉE CHALAMET

Greenwood, Douglas. "How Timothée Chalamet Is Ushering in A New Era for Masculinity." *British Vogue*, September 21, 2019, https://www.vogue.co.uk/arts-and-lifestyle/article/timothee-chalamet-for-new-era-masculinity.

Hattersley, Giles. "The Chalamet Effect: Timothée Talks Fate, Fashion and Being an Old Soul." *British Vogue*, September 15, 2022, https://www.vogue.co.uk/arts-and-lifestyle/article/timothee-chalamet-british-vogue-interview.

Hess, Liam. "Timothée Chalamet Debuts His Most Daring Red Carpet Look Yet." *Vogue*, September 2, 2022, https://www.vogue.com/article/timothee-chalamet-bones-and-all-premiere-haider-ackermann.

CHER

Codinha, Alessandra. "Cher Doesn't Know What You Mean by 'It's Giving Cher.'" *Vogue*, January 4, 2022, https://www.vogue.com/article/cher-uggs-feel?redirectURL=https://www.vogue.com/article/cher-uggs-feel.

Okwodu, Janelle. "75 of Cher's Most Outlandish, Inimitable Outfits." *Vogue*, May 20, 2021, https://www.vogue.com/slideshow/cher-style-evolution-75-greatest-fashion-moments.

Tangcay, Jazz. "Cher's 10 Best Looks of All Time, Hand-Picked by Bob Mackie." *Variety*, May 20, 2021, https://variety.com/lists/chers-10-best-outfits-bob-mackie/prisoner-album-cover-1979/.

QUANNAH CHASINGHORSE

Allaire, Christian. "The Thrilling Ascent of Model Quannah Chasinghorse." *Vogue*, September 9, 2021, https://www.vogue.com/article/quannah-chasinghorse-indigenous-model-profile.

Mailhot, Terese Marie. "Quannah Chasinghorse Is on a Mission." *Elle*, December 14, 2021, https://www.elle.com/fashion/a38388562/quannah-chasinghorse-interview/.

Mazzone, Dianna. "Model Quannah Chasinghorse Gave Us a Tour of Her Alaska Hometown." *Allure*, February 10, 2022, https://www.allure.com/story/model-quannah-chasinghorse-hometown-interview.

EMMA CORRIN

Mescal, Paul. "What You Should Know About Emma Corrin." *Interview*, December 5, 2022, https://www.interviewmagazine.com/culture/what-you-should-know-about-emma-corrin.

Specter, Emma. "Emma Corrin on Fluidity, Fun, and Dressing Up to Stand Out." *Vogue*, July 6, 2022, https://www.vogue.com/article/emma-corrin-august-2022-cover.

Thorne, Will. "Meet Emma Corrin, *The Crown* Star Bringing Princess Diana to Life for a New Generation." *Variety*, November 12, 2020, https://variety.com/2020/tv/features/the-crown-emma-corrin-princess-diana-1234829272/.

DAPPER DAN

Adler, Dan. "Dapper Dan Wants to Understand Every Angle." *Vanity Fair*, July 10, 2019, https://www.vanityfair.com/style/2019/07/dapper-dan-memoir-interview?redirectURL=https%3A%2F%2Fwww.vanityfair.com%2Fstyle%2F2019%2F07%2Fdapper-dan-memoir-interview%3Futm_source%3DVANITYFAIR_REG_GATE&utm_source=VANITYFAIR_REG_GATE.

Nas. "Dapper Dan on Gucci, Gangsters, and His Unstoppable Fashion Empire." *Interview*, May 5, 2018, https://www.interviewmagazine.com/fashion/dapper-dan-gucci-interview.

William Cohen, Trace. "Dapper Dan Shares Insights from His Decades of Influence in New Interview." *Complex*, October 7, 2022, https://www.complex.com/style/dapper-dan-claima-stories-interview.

BILLIE EILISH

Burke, Sinéad. "Oscar Nominees Billie Eilish and Finneas on Fashion, Freedom, and Finding Their Voice for Bond." *Vanity Fair*, February 17, 2022, https://www.vanityfair.com/hollywood/2022/02/awards-insider-billie-eilish-finneas-interview.

Smith, Thomas. "Billie Eilish: 'I Owe it to Everyone to Put on a Good Glastonbury Show.'" *NME*, June 24, 2022, https://www.nme.com/big-reads/billie-eilish-cover-interview-2022-glastonbury-festival-3253169.

Snapes, Laura. "'It's All About What Makes You Feel Good': Billie Eilish on New Music, Power Dynamics, And Her Internet-Breaking Transformation." *British Vogue*, May 2, 2021, https://www.vogue.co.uk/news/article/billie-eilish-vogue-interview.

PALOMA ELSESSER

Hart, Ericka. "Paloma Elsesser: 'I'm Not Wearing a Stretchy Dress. I'm Wearing Miu Miu.'" *i-D*, February 21, 2022, https://i-d.vice.com/en/article/qjbw93/paloma-elsesser-interview.

Okwodu, Janelle. "Role Model: How Paloma Elsesser Is Changing Fashion for the Better." *Vogue*, December 14, 2020, https://www.vogue.com/article/paloma-elsesser-cover-january-2021.

Sevigny, Chloë. "Paloma Elsesser and Chloë Sevigny Do It for the Freaks." *Interview*, October 26, 2022, https://www.interviewmagazine.com/fashion/paloma-elsesser-and-chloe-sevigny-do-it-for-the-freaks.

ELLA EMHOFF

"Ella Emhoff, Artist, Model, and Designer, 23." *Harper's Bazaar*, August 16, 2022, https://www.harpersbazaar.com/culture/a40783090/ella-emhoff-bazaar-icons-interview-2022/.

Krentcil, Faran. "Ella Emhoff Thinks It's Weird She's Famous, Too." *Elle*, October 11, 2021, https://www.elle.com/fashion/celebrity-style/a37886808/ella-emhoff-interview-fashion/.

O. Harris, Jeremy. "The Rise of Ella Emhoff, Newly Minted Style Star." *Interview*, April 16, 2021, https://www.interviewmagazine.com/culture/the-rise-of-ella-emhoff-newly-minted-style-star.

JEFF GOLDBLUM

Heaf, Jonathan. "How Jeff Goldblum Became the Coolest Guy in Hollywood (Again)." *GQ*, July 5, 2018, https://www.gq-magazine.co.uk/article/jeff-goldblum-interview-2018.

Indiana, Jake. "Jeff Goldblum Is 'A Whirligig of Delight.'" Highsnobiety, Accessed January 2, 2023, https://www.highsnobiety.com/p/jeff-goldblum-interview/.

Ottenberg, Mel. "Jeff Goldblum Calls Mel Ottenberg from His Closet." *Interview*, January 25, 2022, https://www.interviewmagazine.com/fashion/jeff-goldblum-calls-mel-ottenberg-from-his-closet.

PEGGY GUGGENHEIM

Amaya, Mario. "Peggy Guggenheim." *Interview*, October 19, 2011, https://www.interviewmagazine.com/art/peggy-guggenheim.

Felsenthal, Julia. "A New Documentary Takes on the Wild, Strange Life of Peggy Guggenheim." *Vogue*, November 6, 2015, https://www.vogue.com/article/peggy-guggenheim-art-addict-lisa-immordino-vreeland.

Singer, Olivia. "How, And Why, To Dress Like Peggy Guggenheim." *British Vogue*, August 25, 2017, https://www.vogue.co.uk/gallery/peggy-guggenheim-style.

JEREMY O. HARRIS

Hine, Samuel. "Fashion's Favorite Playwright, Jeremy O. Harris, Just Dropped a Clothing line with SSENSE." *GQ*, December 16, 2020, https://www.gq.com/story/jeremy-o-harris-ssense-works-collab.

Mukhtar, Amel. "Jeremy O. Harris on Professional Pressures, *Euphoria*, and (Finally) Bringing *Daddy* to London." *Vogue*, March 22, 2022, https://www.vogue.com/article/jeremy-o-harris-daddy-london-debut-interview.

Sinclair Scott, Fiona. "Jeremy O. Harris' Met Gala Outfit Was an Homage to Aaliyah." CNN.com, September 13, 2021, https://www.cnn.com/style/article/jeremy-o-harris-interview-met-gala-aaliyah/index.html.

EDITH HEAD

Alexander, Ella. "Google Celebrates Edith Head." *British Vogue*, October 28, 2013, https://www.vogue.co.uk/article/edith-head-google-doodle-hollywood-costume-designer.

Davis, Allison P. "30 Fantastic Movie Costumes by the Legendary Edith Head." *The Cut*, October 28, 2013, https://www.thecut.com/2013/10/30-fantastic-movie-costumes-by-edith-head.html.

Duka, John. "Edith Head, Fashion Designer for the Movies, Dies." *The New York Times*, October 27, 1981, https://www.nytimes.com/1981/10/27/obituaries/edith-head-fashion-designer-for-the-movies-dies.html.

AUDREY HEPBURN

Harrison, Timothy. "7 of Audrey Hepburn's Greatest Givenchy Moments On-Screen." *British Vogue*, May 30, 2020, https://www.vogue.co.uk/arts-and-lifestyle/gallery/audrey-hepburn-givenchy-film-looks.

Parker, Maggie. "13 of Audrey Hepburn's Most Inspiring Quotes." *Time*, May 4, 2016, https://time.com/4316700/audrey-hepburn-inspiring-quotes/.

Ramzi, Lilah. "A New Audrey Hepburn Documentary Reveals the Life Beyond the Glamour." *Vogue*, December 16, 2020, https://www.vogue.com/article/audrey-more-than-an-icon-documentary.

ELTON JOHN

Cazmi, Mishal. "Elton John's Top 8 Iconic Outfits Throughout the Years." *Hello!*, May 24, 2019, https://www.hellomagazine.com/fashion/gallery/20190524127740/elton-john-most-iconic-outfits/1/.

Lambert, Harper. "Elton John Doubles Down on Retirement After 'Farewell Yellow Brick Road' Tour: 'I've Had Enough Applause.'" *The Wrap*, October 23, 2021, https://www.thewrap.com/elton-john-retire-after-farewell-road-tour/.

Okwodu, Janelle. "Elton John Remains Music's Most Fantastical Star." *Vogue*, May 25, 2021, https://www.vogue.com/slideshow/elton-john-style-evolution-fantastical-music-star.

Spencer, Luke. "Elton John's Life in Looks Proves He's Always Had a Flair for Style." *Vogue*, January 25, 2022, https://www.vogue.com/video/watch/elton-john-life-in-looks.

GRACE JONES

Pelley, Rich. "Grace Jones: 'Even if I Stand on My Head, I Still Can't Do It. How These Young Girls Twerk, I Don't Know." *The Guardian*, September 17, 2022, https://www.theguardian.com/lifeandstyle/2022/sep/17/this-much-i-know-grace-jones-how-these-young-girls-twerk-i-dont-know.

Regensdorf, Laura. "Grace Jones on 'Hippie Acid Love' and the Rain-Soaked Scents of Jamaica." *Vanity Fair*, September 9, 2022, https://www.vanityfair.com/style/2022/09/grace-jones-boy-smells-candle-interview.

Valenti, Lauren. "Happy Birthday, Grace Jones! 18 Times the Fearless Pop Icon Broke the Beauty Mold." *Vogue*, May 19, 2022, https://www.vogue.com/article/grace-jones-best-iconic-beauty-looks-shaved-head-flattop-80s-makeup-slave-to-the-rhythm.

FRIDA KAHLO

Bowles, Hamish. "Behind the Personal Branding of Frida Kahlo." *Vogue*, June 18, 2018, https://www.vogue.com/article/frida-kahlo-making-her-self-up-london.

Healy, Claire Marie. "What Frida Kahlo's Clothing Tells Us About Fashion's Disability Frontier." *Dazed*, June 7, 2018, https://www.dazeddigital.com/fashion/article/40240/1/frida-kahlo-disability-fashion-mexico.

Kahlo, Frida. *Frida Kahlo: The Last Interview*. New York: Melville House, 2020.

REI KAWAKUBO

Betts, Kate. "Rei Kawakubo." *Time*, February 9, 2004, https://content.time.com/time/specials/packages/article/0,28804,2015519_2015392_2015457,00.html..

Kim, Monica. "Rihanna Shuts Down the Met Gala Red Carpet in Comme des Garçons." *Vogue*, May 2, 2017, https://www.vogue.com/article/rihanna-met-gala-2017-red-carpet-dress-comme-des-garcons-best-dressed.

Thurman, Judith. "The Misfit." *The New Yorker*, July 21, 2014, https://www.newyorker.com/magazine/2005/07/04/the-misfit.

Watanabe, Mitsuko. "'The Power of Clothing' According to Comme des Garçons's Rei Kawakubo." *Vogue*, May 18, 2021, https://www.vogue.com/article/comme-des-garcons-rei-kawakubo-spring-2021-interview.

DIANE KEATON

Allaire, Christian. "Five Looks That Prove Diane Keaton Is in a Style League of Her Own." *Vogue*, January 5, 2021, https://www.vogue.com/article/diane-keaton-style-icon-best-looks.

Cristobal, Sarah. "Diane Keaton Doesn't Believe She's a Legend." *InStyle*, July 11, 2019, https://www.instyle.com/celebrity/diane-keaton-august-feature.

Interview. "Diane Keaton Takes Questions from 25 Famous Friends and Fans." *Interview*, June 11, 2021, https://www.interviewmagazine.com/film/diane-keaton-takes-questions-from-25-famous-friends-and-fans.

SOLANGE KNOWLES

Hess, Liam. "Solange's New Art Book Offers a Rare Window into Her Creative Process." *Vogue*, August 24, 2022, https://www.vogue.com/article/solange-past-pupils-and-smiles-book.

Kwateng-Clark, Danielle. "Billboard to Honor Solange with the 2017 Impact Award." *Essence*, October 24, 2020, https://www.essence.com/news/solange-knowles-billboard-american-express/.

Sargent, Antwaun. "Solange Knowles Is Not a Pop Star." *Surface*, January 11, 2018, https://www.surfacemag.com/articles/solange-knowles-is-not-a-pop-star/.

Schultz, Katie. "Solange Knowles Offers a BTS Look at Her Creative Process." *Architectural Digest*, August 23, 2022, https://www.architecturaldigest.com/story/solange-knowles-offers-a-bts-look-at-her-creative-process.

SHIRLEY KURATA

"Editorial." Shirley Kurata, Accessed January 2, 2023, http://shirleykurata.squarespace.com/editorial.

Hallock, Betty. "The Costume Designer at the Center of the Universes." *The New York Times*, June 7, 2022, https://www.nytimes.com/2022/06/07/style/eeaao-shirley-kurata-costumes.html.

Hunt, A.E. "'I Wanted the Hotdog Universe to Cross Over with the Taxes Universe': Costume Designer Shirley Kurata on *Everything Everywhere All at Once*." Filmmaker, April 19, 2022, https://filmmakermagazine.com/114163-interview-costume-designer-shirley-kurata-everything-everywhere-all-at-once/#.Y7NqH-zMJEJ.

YAYOI KUSAMA

Matsui, Midori. "Yayoi Kusama, 1998." *Index Magazine*, 2008, http://www.indexmagazine.com/interviews/yayoi_kusama.shtml.

Northman, Tora. "After 10 Years, Louis Vuitton's Second Yayoi Kusama Collab Is Here." Highsnobiety, May 17, 2022, https://www.highsnobiety.com/p/louis-vuitton-yayoi-kusama-teaser/.

Rodgers, Daniel. "Connecting the Dots on Yayoi Kusama's Relationship with Fashion." *Dazed*, March 22, 2021, https://www.dazeddigital.com/fashion/article/52272/1/yayoi-kusama-polka-dot-japanese-artist-fashion-louis-vuitton-rei-kawakubo.

SPIKE LEE

Hess, Liam. "Spike Lee's Pink Louis Vuitton Suit Won Cannes Opening Night." *Vogue*, July 7, 2021, https://www.vogue.com/article/spike-lee-louis-vuitton-cannes-opening-night.

Rothbart, Davy. "Who Inspires Spike Lee? Michael Jackson, George S. Patton, and the

Wizard of Oz, Apparently." *GQ*, February 13, 2016, https://www.gq.com/story/spike-lee-sundance-interview.

Warhol, Andy. "Q & Andy: Spike Lee." Interview." *Interview*, November 14, 2017, https://www.interviewmagazine.com/culture/q-andy-spike-lee.

ANTONIO LOPEZ

Backman, Melvin. "Fashion Illustrator Antonio Lopez Sketched His Dreams—and Made Fashion Reality." *GQ*, October 22, 2019, https://www.gq.com/story/antonio-lopez-fashion-illustrator.

Borrelli-Persson, Laird. "Before There Were Influencers, There Was Antonio, Illustrator Extraordinaire and Arbiter of Style." *Vogue*, September 5, 2018, https://www.vogue.com/article/antonio-lopez-1970s-sex-fashion-disco-documentary-by-james-crump.

Staff. "Antonio Lopez." *Interview*, March 23, 2017, https://www.interviewmagazine.com/film/antonio-lopez-1.

MADONNA

Gay, Roxane and Arianne Phillips. "Madonna's Spring Awakening." *Harper's Bazaar*, January 9, 2017, https://www.harpersbazaar.com/culture/features/a19761/madonna-interview/.

Naughton, Julie. "Madonna Talks Fashion and Fragrance." *Women's Wear Daily*, April 16, 2012, https://wwd.com/fashion-news/fashion-features/madonna-talks-fashion-and-fragrance-5858639/.

Sollosi, Mary. "Madonna's Fashion Evolution." *Entertainment Weekly*, July 5, 2022, https://ew.com/music/madonna-fashion-evolution/?slide=6066967#6066967.

KRISTEN MCMENAMY

Chamberlain, Vassi. "'I Really Want to Be a Grown-Up, But I Can't': At 56, Kristen McMenamy Remains Fashion's Most Fabulous Eccentric." *British Vogue*, December 6, 2021, https://www.vogue.co.uk/arts-and-lifestyle/article/kristen-mcmenamy-vogue-interview.

Hess, Liam. "Kristen McMenamy Is More Than Your Favorite Instagram Account." *Vogue*, August 13, 2021, https://www.vogue.com/article/kristen-mcmenamy-instagram-looks-interview.

ALESSANDRO MICHELE

Bowles, Hamish. "Inside the Wild World of Gucci's Alessandro Michele." *Vogue*, April 15, 2019, https://www.vogue.com/article/gucci-alessandro-michele-interview-may-2019-issue.

Cardini, Tiziana. "'This Collection Is a True Act of Love'—Alessandro Michele on His Gucci Ha Ha Ha Collab with Harry Styles." *Vogue*, June 20, 2022, https://www.vogue.com/slideshow/gucci-ha-ha-ha-harry-styles-capsule.

Foley, Bridget. "Gucci Confirms Alessandro Michele as Creative Director." *Women's Wear Daily*, January 21, 2015, https://wwd.com/fashion-news/designer-luxury/gucci-confirms-michele-as-creative-director-8127391/.

Sarica, Federico. "Alessandro Michele's Tailoring Revolution." *GQ*, July 18, 2022, https://www.gq-magazine.co.uk/fashion/article/alessandro-michele-interview-2022.

PEGGY MOFFITT

Feitelberg, Rosemary. "Peggy Moffitt Says Fashion Is Dead, But She Is Still Getting into It." *Women's Wear Daily*, March 29, 2016, https://wwd.com/business-news/human-resources/peggy-moffitt-fashion-is-dead-but-she-is-still-getting-into-it-10399621/.

Moore, Booth. "Cultural Touchstone: Peggy Moffitt." *Los Angeles Times*, March 3, 2013, https://www.latimes.com/fashion/la-xpm-2013-mar-03-la-ig-peggy-20130303-story.html.

Vogue. "Little Miss Moffitt." *British Vogue*, November 21, 2003, https://www.vogue.co.uk/article/little-miss-moffitt.

RUPAUL

Phelps, Nicole. "Zaldy Is the Designer RuPaul Wouldn't Go Anywhere Without." *Vogue*, June 28, 2018, https://www.vogue.com/article/rupauls-drag-race-costume-designer-zaldy.

Shepherd, Julianne Escobedo. "RuPual Runs the World." *Spin*, April 1, 2013, https://www.spin.com/2013/04/rupaul-runs-the-world-drag-race-supermodel/3/.

Winfrey, Oprah. "Oprah Talks to RuPaul About Life, Liberty and the Pursuit of Fabulous." Oprah.com, Accessed January 2, 2023, https://www.oprah.com/inspiration/oprah-talks-to-rupaul.

RIHANNA

Hobdy, Dominique. "Rihanna Is Undoubtably a Fashion Icon, Here's Why." *Essence*, October 27, 2020, https://www.essence.com/celebrity/rihanna-undoubtably-fashion-icon-heres-why/#97402.

Karmali, Sarah. "Rihanna Named Fashion Icon." *Harper's Bazaar*, March 24, 2014, https://www.harpersbazaar.com/uk/fashion/fashion-news/news/a26353/rihanna-named-fashion-icon/.

Nnadi, Chioma. "Oh, Baby! Rihanna's Plus One." *Vogue*, April 12, 2022, https://www.vogue.com/article/rihanna-cover-may-2022.

Twersky, Carolyn. "Rihanna Takes Her Baby Bump to the Gucci Front Row." *W*, February 25, 2022, https://www.wmagazine.com/fashion/rihanna-gucci-milan-fashion-week-baby-bump.

SIMONE ROCHA

"About." Simone Rocha, Accessed January 2, 2023, https://shop-us.simonerocha.com/.

Carlos, Marjon. "Has Rihanna Finally Found Her Fashion Match in Simone Rocha?" *Vogue*, September 19, 2015, https://www.vogue.com/article/rihanna-simone-rocha-trends-fashion-week-london.

Hyland, Véronique. "For Simone Rocha, The Personal Is Sartorial." *Elle*, May 3, 2022, https://www.elle.com/fashion/a39830827/simone-rocha-interview-2022/.

A$AP ROCKY

DeLeon, Jian. "Fashion I Like Harry Potter: A Conversation With A$AP Rocky." *Complex*, February 27, 2015, https://www.complex.com/style/2015/02/asap-rocky-interview-adidas-fashion.

Ehrlich, Dimitri. "A$AP Rocky." *Interview*, January 7, 2012. https://www.interviewmagazine.com/music/asap-rocky.

Hine, Samuel. "A$AP Rocky Is the Prettiest Man Alive." *GQ*, May 19, 2021, https://www.gq.com/story/asap-rocky-june-july-2021-cover.

DIANA ROSS

Branch, Kate. "Diana Ross Shares the Diva Beauty Rules, From Dark Sunglasses to a Signature Scent That 'Sings.'" *Vogue*, February 2, 2018, https://www.vogue.com/article/diana-ross-baby-love-you-cant-hurry-love-diamond-diana-the-legacy-collection-perfume-fragrance.

Burrow, Rachael. "27 Showstopping Style Moments from Diana Ross." *Veranda*, March 25, 2021, https://www.veranda.com/luxury-lifestyle/luxury-fashion-jewelry/g35913748/diana-ross-style/.

Valenti, Lauren. "Happy 77th Birthday, Diana Ross! The Pop Icon's Best Beauty Looks of All Time." *Vogue*, March 26, 2021, https://www.vogue.com/article/diana-ross-best-iconic-beauty-looks-hair-makeup-curls-lashes-lips.

JULIA SARR-JAMOIS

Bulteau, Mathilde. "Inside Julia Sarr-Jamois' Wardrobe." *Vogue France*, March 18, 2016, https://www.vogue.fr/fashion/celebrity-wardrobe/diaporama/inside-julia-sarr-jamois-wardrobe-beauty-fashion-interview/26643.

Smith, Celia L. "Closet Envy: Julia Sarr-Jamois." *Essence*, October 28, 2020, https://www.essence.com/news/closet-envy-julia-sarr-jamois-2/.

"Tips and Insights: Julia Sarr-Jamois." *Fashion Journal*, August 18, 2014, https://fashionjournal.com.au/fashion/fashion-news/tips-and-insights-julia-sarr-jamois/.

HUNTER SCHAFER

Baker, Jessica. "Hunter Schafer Is the 2019 Breakout Star We Didn't See Coming." *Who What Wear*, July 11, 2019, https://www.whowhatwear.com/hunter-schafer-euphoria-interview/slide4.

Mlotek, Haley. "Hunter Schafer Steps into the Light." *Harper's Bazaar*, December 1, 2021, https://www.harpersbazaar.com/culture/features/a38248731/hunter-schafer-interview-december-2021-january-2022/.

Schafer, Hunter. "This Fashion Week, Gogo Graham and Hunter Schafer Go Home." *Interview*, February 16, 2022, https://www.interviewmagazine.com/fashion/this-fashion-week-gogo-graham-and-hunter-schafer-go-home.

JEAN SEBERG

Mills, Bart. "A Show-Biz Saint Grows Up, or, Whatever Happened to Jean Seberg?" *The New York Times*, June 16, 1974, https://www.nytimes.com/1974/06/16/archives/a-showbiz-saint-grows-up-or-whatever-happened-to-jean-seberg-jean.html.

Millstein, Gilbert. "Evolution of a New Saint Joan." *The New York Times*, April 7, 1957, https://timesmachine.nytimes.com/timesmachine/1957/04/07/90793155.html?pageNumber=225.

Yaeger, Lynn. "#TBT The Eternal Cool of French New Wave Movie Star Jean Seberg." *Vogue*, November 13, 2014, https://www.vogue.com/article/jean-seberg-french-new-wave-movies.

CHLOË SEVIGNY

Gordon, Kim. "Chloe Sevigny." *Interview*, January 7, 2012, https://www.interviewmagazine.com/film/chloe-sevigny.

Jones, Isabel. "Chloë Sevigny Called Harmony Korine Her 'University.'" *InStyle*, September 10, 2020, https://www.instyle.com/celebrity/tbt-chloe-sevigny-harmony-korine-relationship.

"Unsurprisingly, Chloë Sevigny Is the Coolest Bride Ever." *Vogue*, March 30, 2022, https://www.vogue.com/article/chloe-sevigny-cool-bachelorette-getaway.

HARRY STYLES

Bowles, Hamish. "Playtime With Harry Styles." *Vogue*, November 13, 2020, https://www.vogue.com/article/harry-styles-cover-december-2020.

Elan, Priya. "How Harry Styles Became the Face of Gender-Neutral Fashion." *The Guardian*, November 17, 2020, https://www.theguardian.com/fashion/2020/nov/17/how-harry-styles-became-the-face-of-gender-neutral-fashion#:~:text=Styles%20also%20spoke%20about%20his,extended%20part%20of%20creating%20something.%E2%80%9D.

Maoui, Zak. "Harry Styles Is the Best-Dressed Musician in the World." *GQ*, May 20, 2022, https://www.gq-magazine.co.uk/gallery/harry-styles-best-fashion-moments.

Sheffield, Rob. "Harry Styles Celebrates Historic 15-Show Run at Madison Square Garden with Banner Raising." *Rolling Stone*, September 22, 2022, https://www.rollingstone.com/music/music-news/harry-styles-madison-square-garden-banner-raising-1234597708/.

ANNA SUI

The Cut. "New York Is Still Inspiring Designer Anna Sui." *New York*, March 16, 2022, https://www.thecut.com/2022/03/in-her-shoes-podcast-with-anna-sui.html.

"The World of Anna Suit." Anna Sui, Accessed January 2, 2023, https://annasui.com/pages/anna-sui-about-page.

Yotka, Steff. "Anna Sui." *Vogue*, February 15, 2022, https://www.vogue.com/fashion-shows/fall-2022-ready-to-wear/anna-sui.

TILDA SWINTON

Cusumano, Katherine. "Tilda Swinton's Style Evolution: A Brief History of Her Unique Looks." *W*, July 14, 2021, https://www.wmagazine.com/fashion/tilda-swinton-best-red-carpet-fashion.

Egan, Brenna. "Tough Tilda Goes Soft in Lanvin (And We Like!)." Refinery29, January 30, 2012, https://www.refinery29.com/en-us/sag-red-carpet-tilda-swinton-lanvin.

The National Staff. "Style Quote of the Week: Tilda Swinton." *The National News*, July 13, 2014, https://www.thenationalnews.com/style-quote-of-the-week-tilda-swinton-1.656154.

ANDRÉ LEON TALLEY

Anderson, Tre'vell. "For More than 40 Years, André Leon Talley Has Influenced Fashion and Culture. But It Wasn't Easy." *Los Angeles Times*, May 25, 2018, https://www.latimes.com/entertainment/movies/la-et-mn-andre-leon-talley-gospel-film-20180525-story.html.

Barker, Andrew. "Film Review: *The Gospel According to André*." *Variety*, September 9, 2017, https://variety.com/2017/film/reviews/toronto-film-review-the-gospel-according-to-andre-1202552967/.

Schuster, Dana. "Fashion's New Man of the People." *New York Post*, November 10, 2010, https://nypost.com/2010/11/10/fashions-new-man-of-the-people/.

TYLER, THE CREATOR

Hughes, Aria. "Tyler, the Creator Talks Growing Golf Wang, BET Awards Performance, and His New Love for Vintage Cartier Watches." *Complex*, July 27, 2021, https://www.complex.com/style/tyler-the-creator-golf-wang-golf-le-fleur-new-album-interview/golf-le-fleur.

Nnadi, Chioma. "Tyler, the Creator Is the Fashion Rebel the World Needs Right Now." *Vogue*, November 22, 2019, https://www.vogue.com/vogueworld/article/tyler-the-creator-interview-golf-wang-converse-camp-flog-gnaw.

DIANA VREELAND

Interview. "Life Lessons from Diana Vreeland." *Interview*, October 21, 2021, https://www.interviewmagazine.com/culture/life-lessons-from-diana-vreeland.

Morris, Bernadine. "Diana Vreeland, Editor, Dies; Voice of Fashion for Decades." *The New York Times*, August 23, 1989, https://www.nytimes.com/1989/08/23/obituaries/diana-vreeland-editor-dies-voice-of-fashion-for-decades.html?pagewanted=1.

W.S. Trow, George. "Haute, Haute Couture." *The New Yorker*, May 19, 1975, https://www.newyorker.com/magazine/1975/05/26/haute-haute-couture.

JOHN WATERS

Hubert, Craig. "John Waters Tells the Story of His Mustache." *The New York Times*, August 4, 2016, https://www.nytimes.com/2016/08/04/t-magazine/entertainment/john-waters-mustache-director.html.

Rodgers, Daniel. "Filthy and Fabulous! 5 Times John Waters Influenced Fashion." *Dazed*, April 22, 2021, https://www.dazeddigital.com/fashion/article/52571/1/

filthy-and-fabulous-5-times-john-waters-influenced-fashion.

TODAY contributor. "*Wizard of Oz* still inspiring John Waters." TODAYshow.com, January 10, 2011, https://www.today.com/popculture/wizard-oz-still-inspiring-john-waters-1C9493601.

VIVIENNE WESTWOOD

Flood, Alex. "Vivienne Westwood: 'Oasis? I Heart It in a Taxi Once and Thought: "Is That It?"'" *NME*, May 13, 2022, https://www.nme.com/features/film-interviews/vivienne-westwood-oasis-wake-up-punk-interview-billie-eilish-3225121.

Macias, Ernesto. "Life Lessons from Vivienne Westwood." *Interview*, March 11, 2022, https://www.interviewmagazine.com/culture/life-lessons-from-vivienne-westwood.

Van Den Broeke, Teo. "Dame Vivienne Westwood: 'Boris Johnson Has Never Had an Altruistic Thought. He's Completely Destructive.'" *GQ*, September 3, 2021, https://www.gq-magazine.co.uk/fashion/article/vivienne-westwood-interview.

ZENDAYA

Karmali, Sarah. "Zendaya: 'Knowing Who You Are and What You Stand for Is Important." *Harper's Bazaar*, February 11, 2022, https://www.harpersbazaar.com/uk/culture/culture-news/a39044710/zendaya-squarespace-creativity-success/.

Meltzer, Marisa. "'There's So Much I Want to Do': The World According to Zendaya." *British Vogue*, September 6, 2021, https://www.vogue.co.uk/news/article/zendaya-british-vogue-interview.

Singer, Maya. "With HBO's *Euphoria*, Zendaya Puts Her Disney Past Behind Her Once and For All." *Vogue*, May 9, 2019, https://www.vogue.com/article/zendaya-cover-interview-june-2019.

ACKNOWLEDGMENTS

Thank you to Caron Lee, Seymour Polatin, Juliette Toma, Carly Jean Andrews, and my parents, Lawrence Karman and Sara Schifrin, for your support.

—Bijou Karman

Style Legends, Rebels, & Visionaries
Illustrated by Bijou Karman
Introduction by Booth Moore
Essays by Sara DeGonia

Illustrations ©2023 Bijou Karman All Rights Reserved.

Peggy Moffitt photograph © William Claxton.
Courtesy of Demont Photo Management and
Fahey Klein Gallery.

Publisher: Gloria Fowler, Steve Crist
Editor: Gloria Fowler
Designer and Production: Alexandria Martinez
Production: Freesia Blizard

ISBN: 978-1-7972-2263-9

Library of Congress Cataloging-in-Publication Data available.

Manufactured in China

CHRONICLE CHROMA

Chronicle Chroma is an imprint of Chronicle Books.
Los Angeles, California

Follow us on Instagram @chroniclechroma

chroniclechroma.com